VIEWS OF VENICE BY CANALETTO

Engraved by Antonio Visentini

INTRODUCTION

AND

DESCRIPTIVE

TEXTS

BY

J. G. LINKS

DOVER PUBLICATIONS, INC., NEW YORK

Published in Canada by General Publishing Company, Ltd.,
30 Lesmill Road, Don Mills, Toronto, Ontario.
Published in the United Kingdom by Constable and Company, Ltd.

Views of Venice by Canaletto, first published in 1971, contains all 38 views engraved by A. Visentini, after paintings by Canaletto, originally published by Giovanni Battista Pasquali, Venice, 1742, in the work variously titled *Prospectus Magni Canalis Venetiarum . . .* and *Urbis Venetiarum Prospectus Celebriores . . .* ; these 38 views, as well as the *Prospectus* title page and the page of portraits of Canaletto and Visentini, are reproduced directly from the original edition.

A new Introduction and descriptive texts have been written especially for the present edition by J. G. Links. A map and a selection of related illustrations are also included.

International Standard Book Number: 0-486-22705-7
Library of Congress Catalog Card Number: 77-113990

Manufactured in the United States of America
Dover Publications, Inc.
180 Varick Street
New York, N.Y. 10014

INTRODUCTION
TO THE DOVER
EDITION

Three men combined to produce this book: Joseph Smith, an English businessman resident in Venice who was about sixty when its first edition, containing only the first fourteen engravings, was published in 1735, and two artists he patronised, Antonio Visentini and Giovanni Antonio Canal. Visentini was fourteen years younger than Smith, having been born in Venice in 1688, and was an "artist" in the eighteenth-century sense of the word— that is to say, he painted wall decorations and easel pictures, reconstructed and designed houses, including two for Smith, and drew bookplates and ornamental designs for printers. It is as an engraver, though, that he is chiefly remembered and above all as the engraver of this book.

Canal, known as Canaletto to distinguish him from his father Bernardo, was born in 1697 and was thus young enough to be Smith's son. By 1735 he was at the height of his reputation as the first artist to carry townscape painting into the realms of both art and professionalism. For the art he must have owed much to his father and to his early training as a theatrical designer; by the time he was twenty-five he had made the city of Venice the subject to which he was to devote most of the rest of his life. He never surpassed the master-pieces which he painted in the following few years (amounting only to some two dozen) but he was then taken up by Smith, to whom he probably owed much of his professionalism.

Smith certainly bought or commissioned the first fourteen paintings engraved in this book and he may well have owned the remaining twenty-four as well. He may also have acted as selling agent for the artist, introducing his work to the great English collectors such as the Dukes of Bedford and Buckingham and Earl Fitzwilliam, whose descendants in many cases still own them; none of this can be said with certainty, however. Horace Walpole went so far as to say that "Mr Smith engaged him [Canaletto] to work for him for many years at a very low price & sold his works to the English at much higher rates," but Walpole did not like Smith, whom he called "the merchant of Venice." Moreover, it would have been difficult to persuade Canaletto to work for a very low price at a time (1727) when, according to Owen McSwiney, the Duke of Richmond's buying agent, he was

"whimsical and varys his prices every day . . . He has more work than he can doe, in any reasonable time, and well."

Uncertainty also surrounds the dates when the first fourteen paintings were executed. In 1730 Smith wrote to Samuel Hill, an English friend whose nephew had been apprenticed to him, "The prints of the views and pictures of Venice will now soon be finished. I've told you there is only a limited number to be drawn off, so if you want any for friends, speak in time." This has led W. G. Constable, Canaletto's biographer and cataloguer, to conclude that all the paintings were finished by that time (1730) as they were already being engraved by Visentini. The first four reproduced in this book most probably were in existence by then, judging by the evidence of their style, so perhaps were numbers VII and VIII; the re-mainder of the first twelve seem to be later. Numbers XIII and XIV, the two large festival pictures, were certainly the last to be painted and were probably added to the book as an afterthought: all the others are views of the Grand Canal, as promised by the main title-page (*Prospectus Magni Canalis*), these last two being "addito Certamine Nautico et Nundinis Venetis" (Nautical Contest and Venetian Market).

The paintings were certainly finished by 1735 and so were Visentini's engravings of them, and the book appeared with its title-page, *Prospectus Magni Canalis . . .*, making it clear that the paintings were "in Aedibus Josephi Smith Angli," in the house of Joseph Smith, Englishman. Following the title-page appeared portraits of Canaletto and Visentini, that of Canaletto being the only authentic likeness of him known. The paintings remained in Smith's possession for another twenty-five years, after which he sold his collection, almost in its entirety, to George III, hence the fifty paintings and 143 drawings by Canaletto now in the Royal Collection at Windsor, England.

In 1742 a new edition of the book appeared and twenty-four new engravings were added to the original fourteen; this is the edition reproduced in the present book. It contained the original title-page promising a prospect of the Grand Canal, to which was added the

words "Elegantius recusi, Anno MDCCXLII" implying the re-cutting of any worn parts of plates.★ In a number of copies, although not all, there is a second title-page, *Urbis Venetiarum* . . . (Fig. 1), referring to views of the City of Venice in three parts. The first part consisted of the original twelve Grand Canal and two regatta views; the second part contained another ten Grand Canal views and two taken in opposite directions from the Molo (mole, or quay); the third part showed ten churches with their *campi*, or adjoining squares, and two views of the Piazza S. Marco in opposite directions. This second title-page bears the imprint of J. B. Pasquali, a well-known publishing firm closely associated with, and largely financed by, Joseph Smith.

Were the twenty-four pictures reproduced in the second and third parts Smith's or not? One of them, Part III, No. 1 (SS. Giovanni e Paolo), certainly was: it is still in the Royal Collection. Another three are among the twenty-four paintings bought by the Duke of Bedford, now at Woburn Abbey, England; two are among the eight bought by Earl Fitzwilliam, now at Milton Park, England; and eight (or probably nine, as will be seen from the note on Part II, No. 3) among the twenty-one which seem to have been bought by the Duke of Buckingham, which became known as the Harvey series and are now dispersed.

The question of Smith's ownership is of particular interest since, if he did own the paintings reproduced here and now in the collections referred to, he must surely have owned all the other Canaletto paintings in those collections, or at any rate have negotiated their sale to the visiting Englishmen who bought them. If he did not own them, who did? And how came they to be included in the album of engravings reproduced here which was still issued with the title-page bearing the words "in the house of Joseph Smith, Englishman"? It is a perplexing problem and it is not made any easier to solve by the remaining evidence, which takes the form of two most interesting sets of drawings.

The first set is contained in a calfbound book which Smith sold to George III with the rest of his collection and which George IV gave to the British Museum in 1823 with part of his library, evidently thinking it to be a book of engravings. It remained in the Museum library for over a century when it was recognised as a book of original drawings and transferred to the appropriate department. There are forty-five drawings, consisting of the thirty-eight published, the *Prospectus Magni Canalis* title-page (but not the *Urbis Venetiarum*), the page containing the portraits of Canaletto and Visentini, and a drawing of one of Smith's bookplates. The remaining four drawings are of Canaletto views which were never included

★ This title-page, as well as the page of portraits, which also appeared in the 1742 edition, are reproduced in the present volume. The Latin list of plates ("Tabularum Series") has been omitted.

URBIS
VENETIARUM
PROSPECTUS CELEBRIORES,
EX
ANTONII CANAL TABULIS XXXVIII.
AERE EXPRESSI AB
ANTONIO VISENTINI.
IN PARTES TRES DISTRIBUTI.
PARS PRIMA.

VENETIIS
APUD JOANNEM BAPTISTAM PASQUALI.
MDCCXLII.

FIG. 1. The second title-page, *Urbis Venetiarum* . . ., found in some copies of the 1742 edition. It functioned as a part-title also; note the "Pars Prima."

among those engraved. Two of these belonged to the Harvey series of which eight or nine, as we have seen, *were* engraved. Smith's catalogue of his paintings referred to "12 Peices of Views of the Grand Canal at Venice, being those engraved by Visentini of which the original desyns are in collection of desyns in the Book No. 6," and there can be little doubt that the book now in the British Museum is Smith's "Book No. 6." There is a clear implication, too, that just as the engravings were by Visentini so were the "original desyns" in the book.

The Correr Museum in Venice also has an album of forty-five drawings, but five of them are larger than the rest and, in the present writer's opinion, later.★ The same four views which were never engraved are included, as in the case of the British Museum album, and

★ One of them shows Smith's new house (see note to Part I, No. VIII) which was not finished until 1751. Since this drawing must have been made after the 1742 edition was published it is reasonable to assume that the other four were also outside the series of forty-one drawings of uniform size.

there is a fifth which was never engraved and for which no original painting has yet been found. There is no drawing for three of the engravings. The Correr drawings are quite different from the British Museum ones, being in outline only with squaring up in pencil whereas those in the British Museum are as elaborate as the engravings themselves (for which they were so long mistaken). On the back of the album is inscribed "Disegni Originali di Antonio Canaletto" but the suggestion that the drawings are by Canaletto cannot be taken seriously—even though some of them have a title written in by a hand which resembles that of Canaletto. Apart from their quality, there is no reason to suppose that Canaletto would, at the height of his success, have undertaken the relatively menial task of making drawings from his paintings for Visentini to engrave, although he may well have helped with the sorting and titling of them. The drawings in the Correr Museum and those in the British Museum are exactly what one would expect as two successive stages in the preparation of

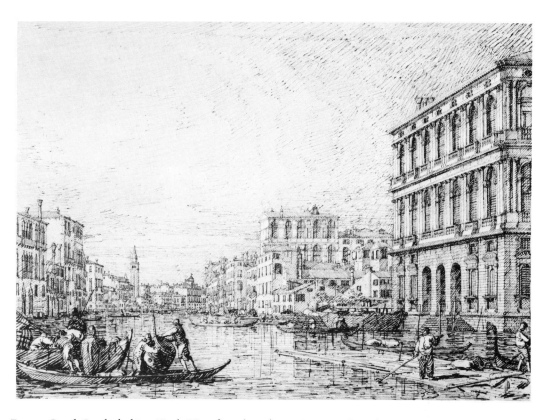

FIG. 3. *Grand Canal: looking North-West from the Palazzo Corner to the Palazzo Contarini dagli Scrigni.* Pen and brown/black ink over pencil, with occasional ruled lines. $10\frac{5}{8} \times 14\frac{5}{8}$ inches. H. M. The Queen, Windsor Castle (Cat. No. 7470; Royal Collection, copyright reserved). Compare Part II, No. 10.

engravings. The natural inference is that Visentini drew both sets himself and, although there is no certainty in the matter, it would be reasonable to draw this conclusion.

Visentini's engravings are of the highest documentary and topographical interest but as works of art they cannot compare with the best of Canaletto's own drawings and etchings. Almost half the total number of Canaletto drawings now existing were contained in a leatherbound volume sold by Smith with the rest of his collection to George III. These 143 drawings provide striking evidence of Canaletto's mastery of the pen and a number of them are of subjects for which there are paintings engraved by Visentini and reproduced in this book. Although there are no drawings identical to such paintings, comparison of the drawing of *S. Geremia and Cannaregio* (Fig. 2), for example, with Visentini's engraving Part I, No. x

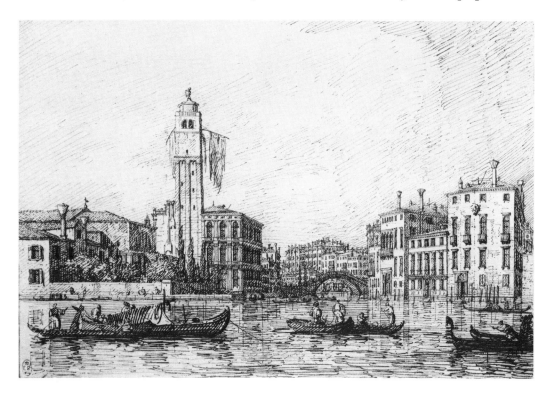

FIG. 2. *Grand Canal: S. Geremia and the Entrance to the Cannaregio.* Pen and brown/black ink over pencil. $7\frac{3}{8} \times 10\frac{5}{8}$ inches. H. M. The Queen, Windsor Castle (Cat. No. 7475; Royal Collection, copyright reserved). Compare Part I, No. x.

described on the title-page not just as "Josephi Smith Angli," as in the case of *Prospectus Magni Canalis*, but as "Ill.mo Signor Giuseppe Smith/ Console di S. M. Britanica," having been appointed British Consul in 1744. Canaletto's painting had by this time become mechanical and repetitive but the new medium seems to have given him fresh impetus. The thirty etchings are among Canaletto's most sensitive and imaginative work as the reproduction (Fig. 5) of *le Preson. V.* (The Prison, Venice) shows. There is no painting or drawing from this exact viewpoint but Visentini's engraving Part II, No. 11 shows the same scene from a little farther away and there is an equivalent drawing from the Correr Museum series (Fig. 6). The reader can thus compare the British Museum drawing (not reproduced here, but indistinguishable from the engraving, Part II, No. 11) with the Correr drawing and both with the product of the master himself.★

★ For purposes of further comparison, four of the original Canaletto paintings after which Visentini made his engravings are reproduced in Figures 7 to 10 at the end of this Introduction.

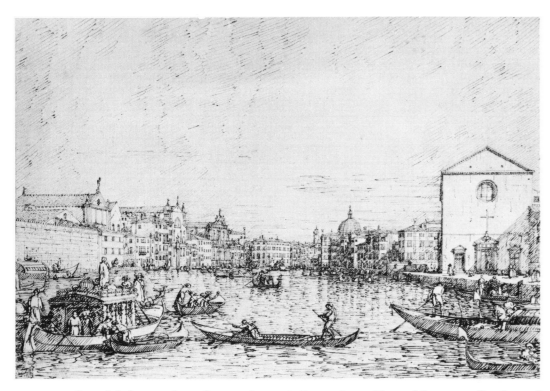

FIG. 4. *Grand Canal: looking North-East from Sta. Croce to S. Geremia*. Pen and brown ink over pencil. 10⅝ × 14⅞ inches. H. M. The Queen, Windsor Castle (Cat. No. 7472; Royal Collection, copyright reserved). Compare Part II, No. 2.

is revealing. Even more so, perhaps, is a comparison of the Windsor drawing *Grand Canal: looking North-West from the Palazzo Corner* (Fig. 3) with Visentini's engraving Part II, No. 10 or of the drawing of the *Grand Canal: looking North-East from Sta. Croce* (Fig. 4) with Visentini's engraving Part II, No. 2.

It was probably about the time that the 1742 edition of this book was published that Canaletto became interested, for the first time in his career, in the art of etching. The War of the Austrian Succession had at this time greatly reduced the number of tourists visiting Venice and Canaletto must have found the demand for his work diminishing (in 1746 he decided that his prospects would be better in England, where so many of his patrons resided, and he left Venice, remaining in England for ten years except for two short visits to his home city). His only volume of etchings was published about 1745 and by this time Smith was

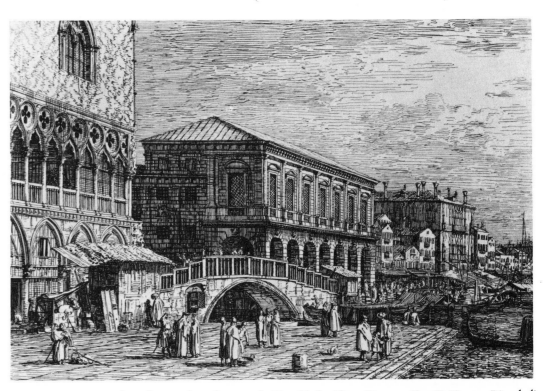

FIG. 5. *le Preson. V.* Etching from *Vedute Altre prese da i Luoghi altre ideate*. Compare Part II, No. 11, *Riva degli Schiavoni, looking East*.

The 1751 edition was the last published in Smith's lifetime. The subsequent history of the plates need not concern us here except to mention that they were probably bought from Smith's widow by a publisher named Furlinetto who had them re-engraved, and that a new edition with Italian and French titles, instead of those in Latin, was published in 1833 and reprinted in 1836.★ Engravings from these or subsequent plates can be bought in Venice to this day.

Canaletto, the youngest of the trio who created this book, was the first to die, in 1768. After his return to Venice from England in about 1756 he did relatively little work but at long last he was, in 1763, elected to the Venetian Academy which had hitherto regarded a view painter, even as eminent as Canaletto, as ineligible.

Visentini was in his eighties when Canaletto died and Smith well in his nineties, although age had not prevented Smith from remarrying ten years earlier. His first wife, an opera singer, had been insane for almost fifty years and his new wife was the sister of John Murray; Murray, a few years earlier, had been appointed British Resident in Venice (see note to Part I, No. XII) to the disappointment of Smith, who himself coveted the senior post. In 1760, two years after his marriage, Smith retired from the consulate and soon after he sold his collection to George III. He died two years after Canaletto, at the age of ninety-six or thereabouts.

Visentini had twelve more years to live, dying in 1782 when he was ninety-four. James Wyatt, the English architect, was in Venice about the time Canaletto died and he studied under Visentini, whom he later described to Joseph Farington, the artist and diarist, as being "100 years of age" (quite wrongly). Farington recorded Wyatt's description of Visentini—"a very temperate man, went to bed and rose with the sun. On Sundays he for many years indulged himself in drinking a bottle of Burton Ale, which was procured for him by Mr. Smith, the old English Consul—his associate and friend."

And so at long last we have a fleeting personal glimpse of, at any rate, two members of the trio before they depart into the shadows. Indeed they have hardly emerged as living people. No personal letter written by any of them has come to light. Canaletto was never married and Smith in name only for fifty years; if Visentini married there is no record of it. We can still see Visentini's work in the façade of Smith's palace, the Mangilli-Valmarana, on Venice's Grand Canal near the Rialto Bridge, and also in the Palazzo Giusti, a little farther

★ A much more logical sequence was followed in this edition, the engravings proceeding up the Grand Canal in correct order, then turning and ending at the Salute where they had begun.

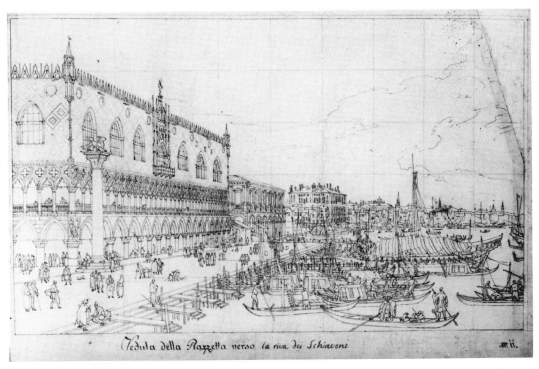

FIG. 6. *Riva degli Schiavoni: looking East.* Outline drawing in pen and brown ink over pencil, squared up in pencil. $10\frac{1}{8} \times 16\frac{5}{8}$ inches. Compare Part II, No. 11. Correr Museum, Venice.

In 1740, two years before the publication of the first complete edition of this book, Smith acquired a small palace on the Grand Canal and engaged Visentini to reconstruct its façade entirely. The work took a very long time as we know from the fact that Marieschi shows it in progress in a painting in the Fitzwilliam Museum, Cambridge: Marieschi died in 1743 whereas, according to Pietro Gradenigo, a Venetian diarist of the period, the façade was not unveiled to the public until 1751. As will be seen in the note on Part I, No. VIII, Smith later called Canaletto in to repaint that part of his picture in order to show the new palace but he never had the engraving altered. This would not, of course, have been possible for the 1742 edition but in 1751, the year the palace was completed, another edition was published and one would have expected Visentini to want to record his work for the public (as the note on Part I, No. X shows, he had already made one alteration to the 1742 edition to bring it up to date). Perhaps Smith was less interested in this edition, having sold all the paintings except the original fourteen and one of the second twenty-four.

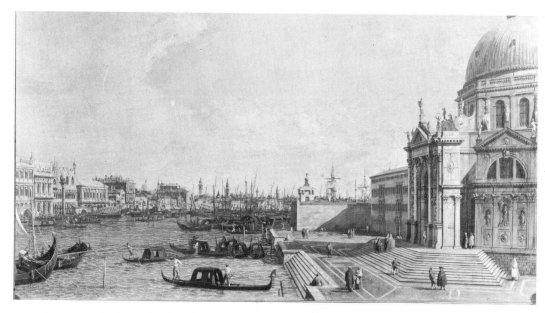

FIG. 7. *Entrance to the Grand Canal: looking East*. Original painting for Part I, No. v. H. M. The Queen, Windsor Castle (copyright reserved).

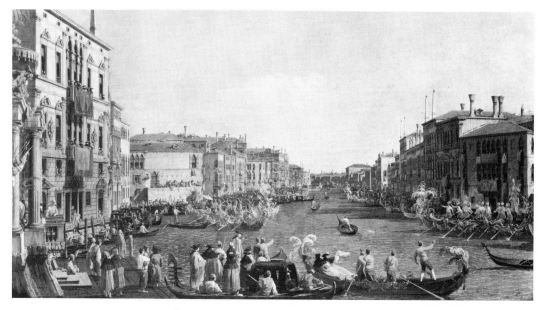

FIG. 9. *A Regatta on the Grand Canal*. Original painting for Part I, No. XIII. H. M. The Queen, Windsor Castle (copyright reserved).

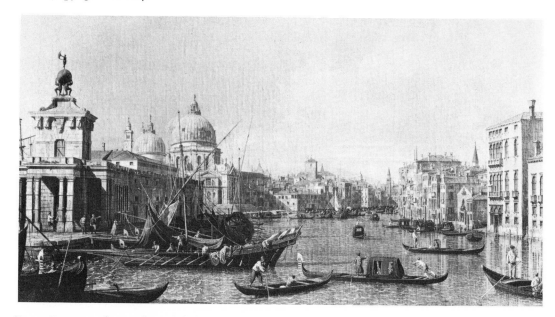

FIG. 8. *Entrance to the Grand Canal: looking West*. Original painting for Part I, No. VI. H. M. The Queen, Windsor Castle (copyright reserved).

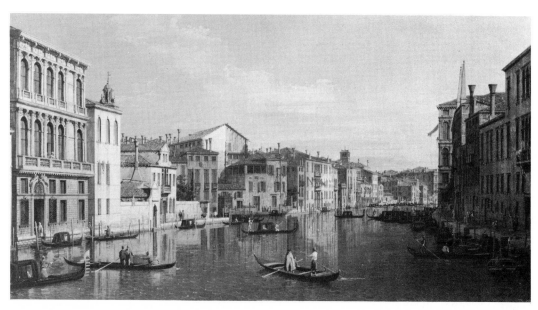

FIG. 10. *Grand Canal: looking East from the Palazzo Flangini to S. Marcuola*. Original painting for Part II, No. 3. Mr and Mrs Charles Wrightsman.

up, which is now part of the Ca' d'Oro. We can still occasionally see part of Smith's lifework, which was the amassing of the collection which now belongs to the Queen (including eight paintings of English houses in capricious settings on which Visentini collaborated with Francesco Zuccarelli to Smith's order).

As for Canaletto, it is impossible to go to Venice without being acutely conscious of the work he did there. Not one of his views remains there, the English having taken them all, but no one who knows his paintings can look at the streets and canals without seeing them partly through Canaletto's eyes.

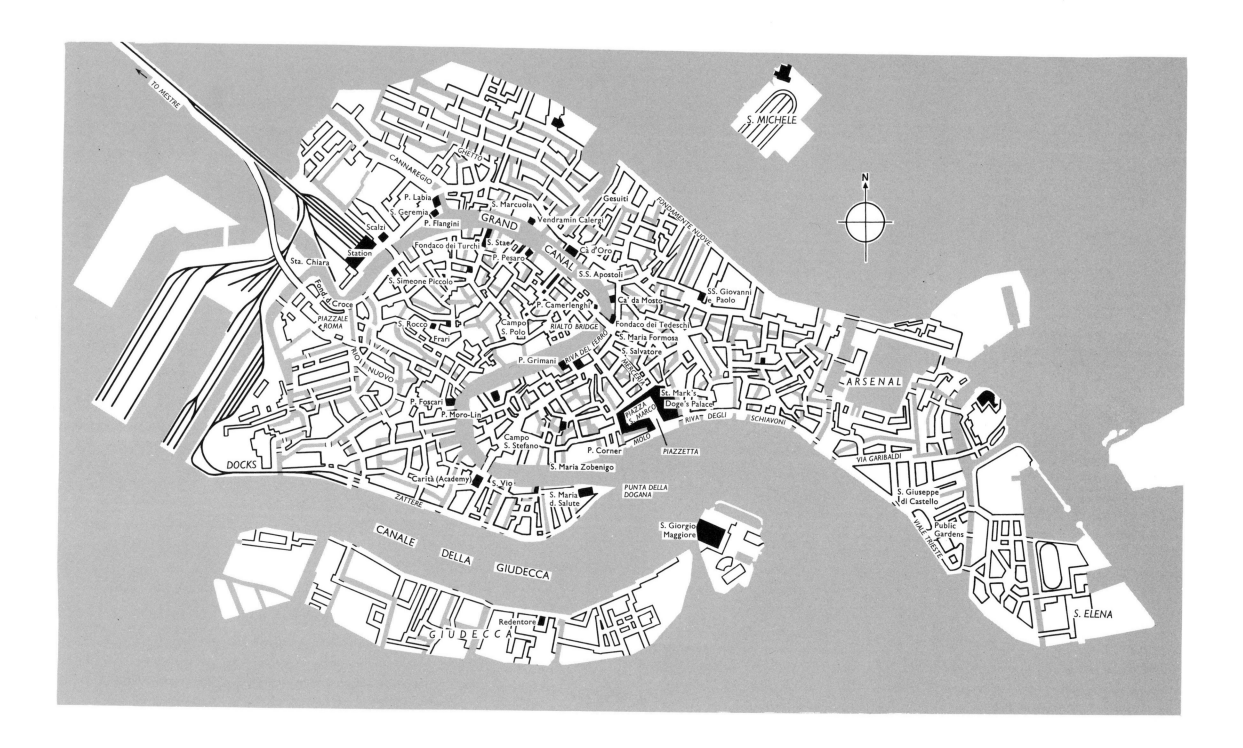

LIST OF PLATES

THE PLATES

NOTES

The next two pages reproduce, from the original edition, the portraits of Canaletto and Visentini drawn and engraved by Visentini after a monochrome by Giovanni Battista Piazzetta, and the *Prospectus* title-page, drawn and engraved by Visentini, with lettering by Angela Baroni.

The engraved views, with their descriptive text, follow. A few points should be kept in mind when reading the descriptions:

1. References to "Constable" are to the book *Canaletto* by W. G. Constable, Oxford, 1962. The English titles to the engravings are those used for the corresponding painting in Constable's catalogue.

2. Unless stated to the contrary, the correspondence of the engraving to the original painting referred to is exact.

3. The original size of the engravings, including title, is $10\frac{3}{4} \times 17$ inches. The approximate size of the original paintings is 19×31 inches unless otherwise stated.

4. The original paintings of the first fourteen engraved views are in the possession of H. M. the Queen, Windsor Castle, England.

5. "Down the Grand Canal" is used to mean in a direction from the station towards Sta. Maria della Salute, and "up" in the opposite direction.

6. Abbreviations: S. = San (Saint)
Sta. = Santa (female Saint)
SS. = Santi (Saints)

The words *di*, *della*, etc. (of) are generally omitted.

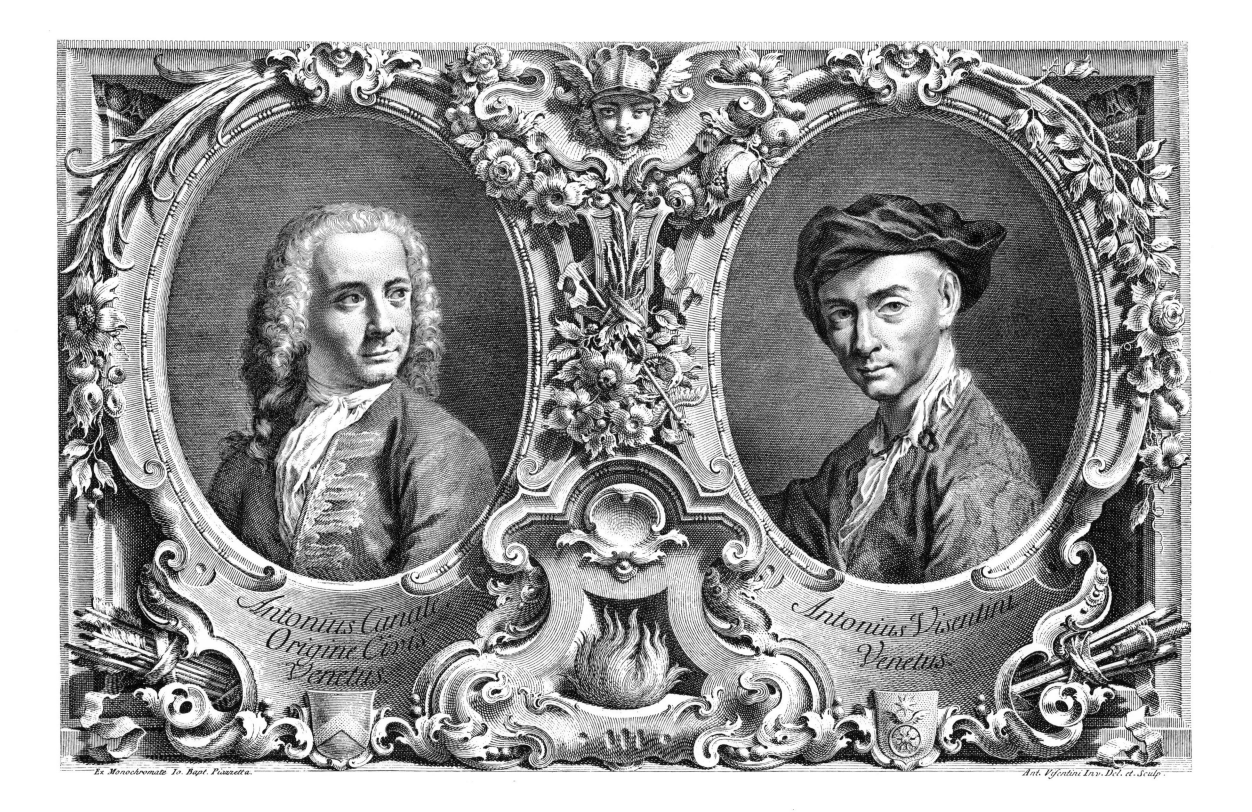

Antonius Canale
Origine Civis
Venetus

Antonius Visentinus
Venetus

Ex Monochromate Io. Bapt. Piazzetta.

Ant. Visentini Inv. Del. et Sculp.

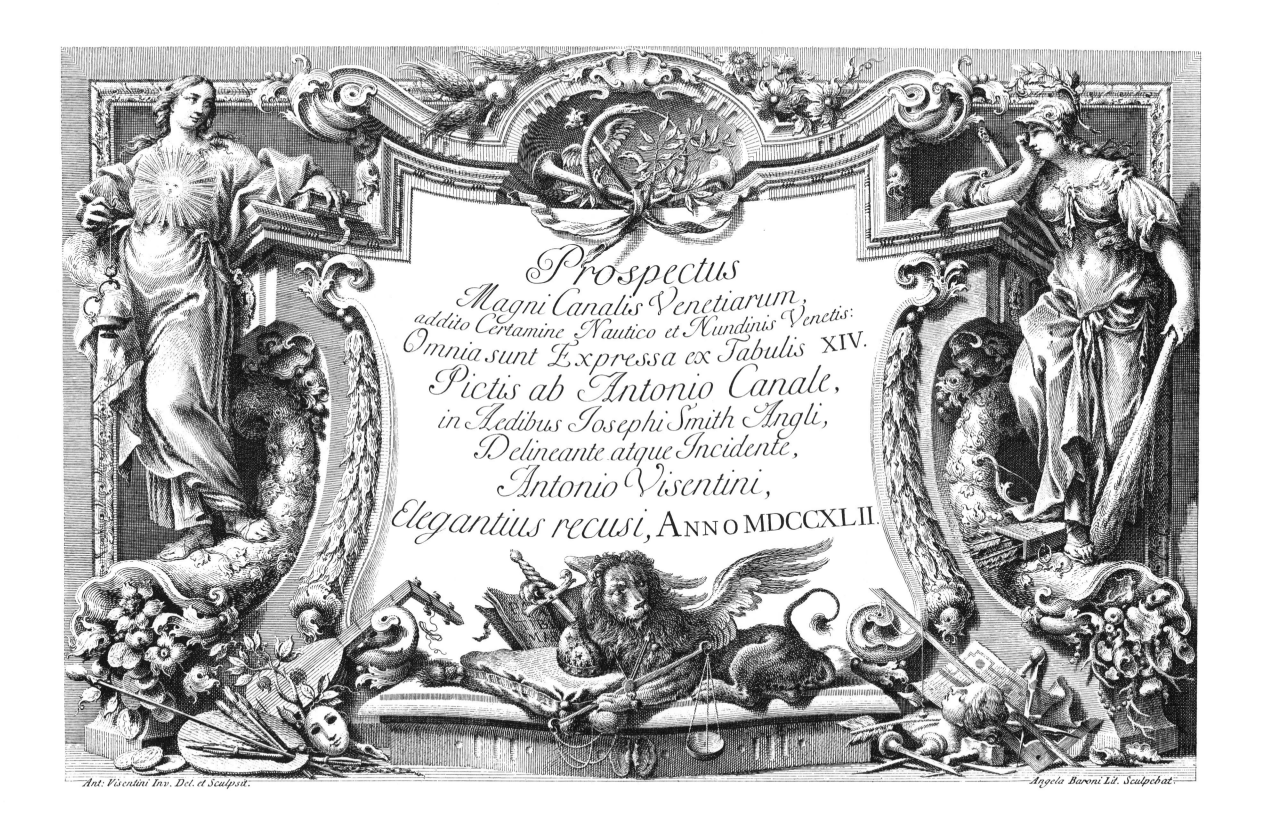

Prospectus

Magni Canalis Venetiarum,
addito Certamine Nautico et Nundinis Venetis:
Omnia sunt Expressa ex Tabulis XIV.
Pictis ab Antonio Canale,
in Aedibus Iosephi Smith Angli,
Delineante atque Incidente,
Antonio Visentini,
Elegantius recusi, Anno MDCCXLII.

Ant: Visentini Inv. Del. et Sculpsit.

Angela Baroni Lit. Sculpebat.

Grand Canal: looking South-West from the Rialto Bridge to the Palazzo Foscari.

For their first engraving Smith and Visentini chose Canaletto's painting showing the scene from the Rialto Bridge, looking down the Grand Canal. It was, and still is, the business and municipal heart of Venice as opposed to the ceremonial heart in the area of the Piazza S. Marco. "Now, what news on the Rialto?" cried Salanio in *The Merchant of Venice*, for it was here that the bankers and merchants gathered to gossip and trade. Their houses line both banks of the Grand Canal and their barges load and unload their merchandise.

On the left is the Riva del Ferro, named after the iron which used to be unloaded here; on the right is the Riva (or Fondamenta) del Vin (the "Ripa Vinaria" of the Latin title), formerly used for the unloading of wine barrels. Throughout the whole length of the Grand Canal it is only along these two quays that one can walk beside it for any considerable distance. The Riva del Ferro, on the left, changes its name to become the Riva del Carbon (coal) and comes to an end only when it reaches the huge Palazzo Grimani in the mid-distance (behind the right-hand of the two flags): this sixteenth-century palace, built by Michele Sanmichele for a family who provided Venice with three Doges, became the post office in 1806 and is now the Court of Appeal. Beside it, as John Ruskin pointed out, are three-storied palaces which reach only to the cornice which marks the level of the first floor of the Grimani palace; yet its perfect scale keeps the façade proportionate to those of its neighbours.

All the buildings on the left still stand, although some have been drastically restored. Beyond the house in the left foreground, with shops below, is a series of palaces of varying age including two, the Farsetti and the Loredan, which were of Byzantine origin and already five hundred years old in Canaletto's time. The Fondamenta del Vin, on the right, is lined with shops and houses above them of no architectural interest. Cafés and restaurants have replaced them today and this is still the busiest part of Venice.

In the far distance the Grand Canal takes its great turn to the left so that the Palazzo Foscari faces directly towards the Rialto Bridge; it is a superb Gothic palace which it will be possible to study at closer quarters in a later engraving.

There is a curious mistake in the Latin title which describes the scene as "towards the east" whereas it is in fact towards the south-west. Constable (p. 275) describes the wooden hut in the left foreground as "perhaps for storing workman's tools" but it seems more likely that the two figures are buying lottery tickets from the man inside.

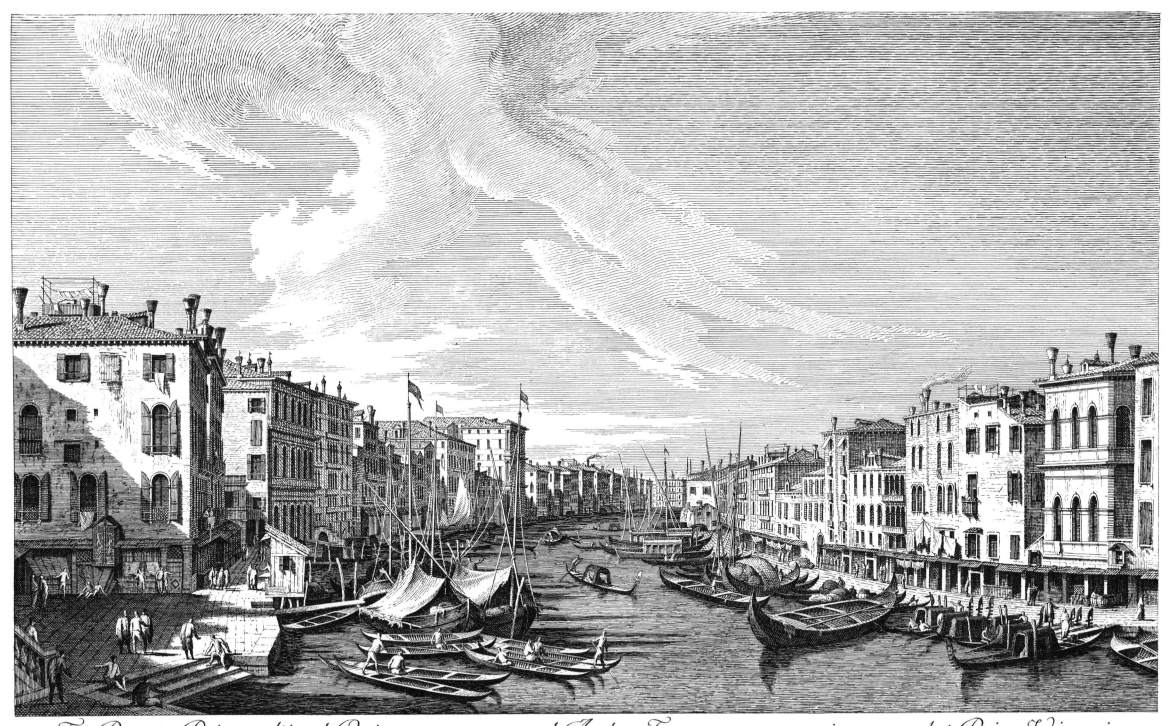

Ex Ponte Rivoalti ad Orientem, usque ad Aedes Foscarorum, cui respondet Ripa Vinaria. I

PART ONE / NO. II
Grand Canal: looking South from the Palazzi Foscari and Moro-Lin to Sta. Maria della Carità.

The second engraving shows the Grand Canal just after it has turned at the Palazzo Foscari, which is on the extreme right of the picture; from a window of this palace the spectator would be looking up the Canal towards the Rialto Bridge. Looking down the Canal there is a short, straight stretch before it curves again to the left, where the Accademia Bridge is today.

On the left is part of the early seventeenth-century Palazzo Moro-Lin, called "dalle tredici finestre" from its thirteen windows on each storey. Beyond it are palaces which were taken down when the massive Palazzo Grassi was built for the Grassi family; they had been admitted to the Venetian aristocracy only in 1718 and had not begun their palace when Canaletto painted his picture. The little *campo* of S. Samuele can be seen in front of the Palazzo Malipiero, the side windows of which look up the Canal towards the spectator. In the distance there is the top of a campanile: this belonged to the Church and Scuola of the Carità (the "Templum Charitatis" of the Latin title), the façade of which can just be seen in the distance and appears in the next picture. It is on the right bank of the Canal.

Beyond the Palazzo Foscari on the right are the three Giustinian palaces built for a family which meant so much to Venice that, in the twelfth century, when all of them except one monk had been killed or died of plague, the Senate petitioned the Pope to release the monk from his vows. The young Nicolò Giustinian then married the Doge's daughter and, after fathering nine sons, returned to his cloister.

Like the Giustinian palaces, the Foscari palace was built in the early fifteenth century when Venice was at the height of her prosperity. Francesco Foscari was elected Doge in 1423 in spite of the warning of his predecessor, Doge Tommaso Mocenigo, that he would bring nothing but wars to Venice. At first the wars were successful but after thirty-four years, and a scandal involving Foscari's son, the Senate decided that Mocenigo's warning had been justified. Foscari was called upon to abdicate and quit his palace within eight days. As he left, it was suggested that he should use the covered stairs but he replied, "No, I will go down the same way I came up." He died a week later of a broken heart.

Beyond is the celebrated Palazzo Rezzonico, where Robert Browning died, now a museum of eighteenth-century Venice. As can be seen, it still lacked the top storey when Canaletto painted his picture.

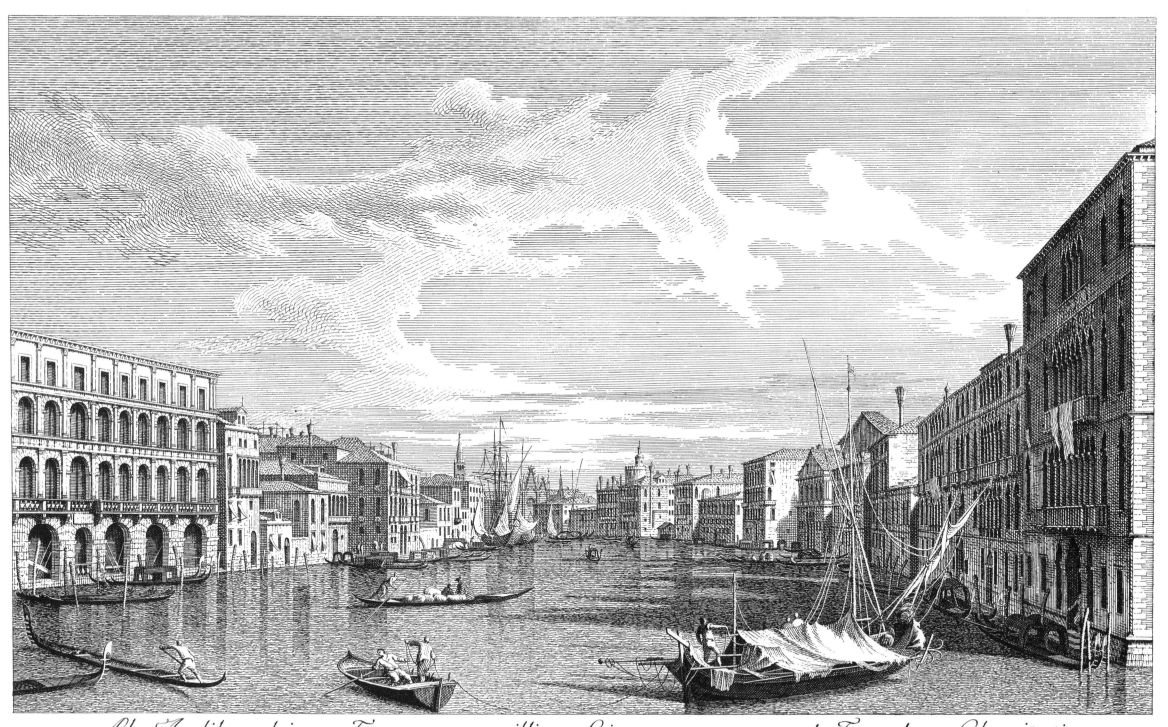

Ab Aedibus hinc Foscarorum, illinc Linorum, usque ad Templum Charitatis.

II.

Grand Canal: from Sta. Maria della Carità to the Bacino di S. Marco.

Again Canaletto moved down the Grand Canal for his picture, and now the end of the Canal has come into view with the Custom House ("Telonium" of the Latin title) and some of the buildings beyond it along the Riva degli Schiavoni. In the foreground are the buildings of the church, convent and *scuola* (guild) of Sta. Maria della Carità (Charity) with their campanile. The Gothic church was built in 1466 and the convent, by Palladio, in 1552. Beyond them can be seen some of the buildings surrounding the Campo S. Vio ("S. Vitalis").

The first complete palace to be seen on the left bank is the Palazzo Cavalli, then a fine example of Venetian Gothic but restored and disfigured in 1896. Beyond it is the Palazzo Barbaro in which Henry James set the scene for *The Wings of the Dove*. When John Ruskin was in Venice in 1851 two old brothers, the last of this once powerful family, were reduced to living in the garret, which is seen in the picture. Ruskin could not forgive the Barbaro family for having built the church of Sta. Maria Zobenigo (see Part III, No. VI) and he wrote to his father, "So they have been brought to their garrets justly." The last building to be seen on the left bank is the side wall of the huge Palazzo Corner della Ca' Grande.

Although many of the buildings shown are still standing, the scene has changed greatly today. The canal in the foreground has been filled in. The Carità buildings now house the Academy of Fine Arts, with its magnificent collection of Venetian paintings. The campanile collapsed in 1744 and on the spot where it stood there was erected in 1854 one end of an iron bridge, the first bridge to be built across the Grand Canal since the original Rialto Bridge. This was replaced in 1932 by a wooden bridge intended to be temporary, but still standing. The building of which part appears on the extreme left of the picture had been taken down by the Count of Chambord earlier in the nineteenth century to make a garden for the Palazzo Cavalli and the other end of the bridge now occupies this space.

Canaletto painted one of his earliest pictures, now in Montreal, from this viewpoint in 1726. It shows the quay in bad condition and a later version shows it under repair. By the time he painted Joseph Smith's version, reproduced here, the quay had been repaired, a slight but useful clue in the difficult problem of dating the series.

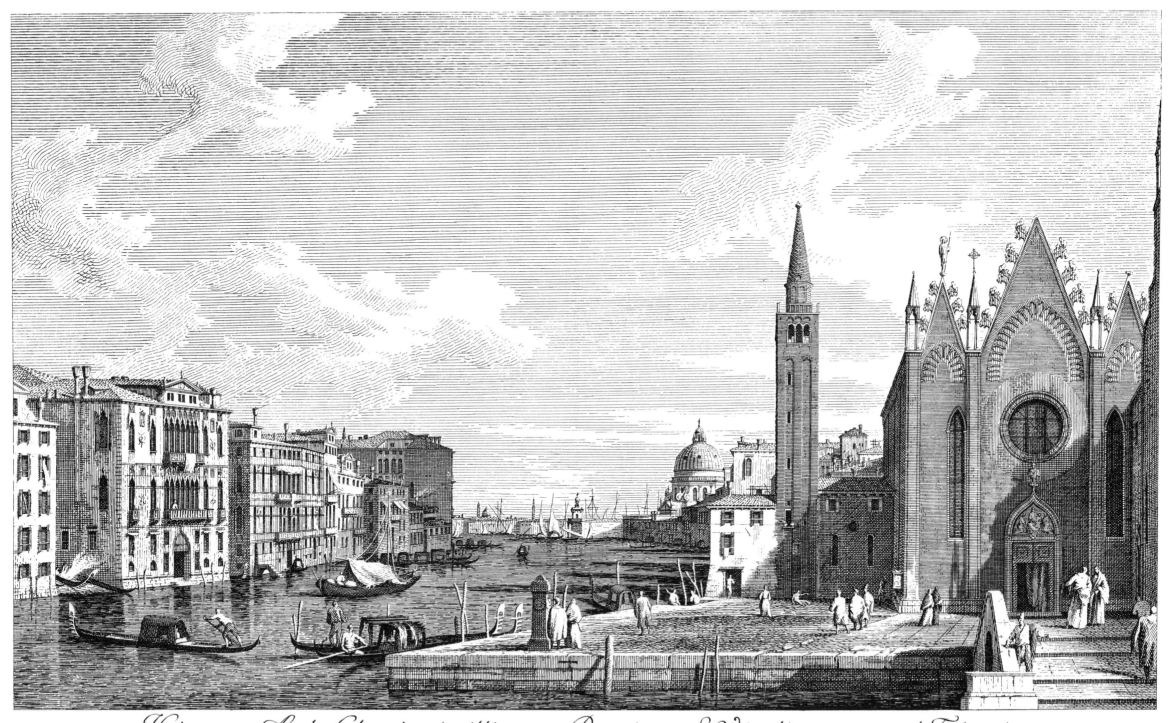

Hinc ex Aede Charitatis, illinc ex Regione S. Vitalis usque ad Telonium.

III.

Grand Canal: looking East from the Campo S. Vio.

Above the small house on the left of the campanile in the last picture can be seen the side of another house in the distance. This was the Palazzo Barbarigo on the Campo S. Vio, a hundred yards or so lower down the Grand Canal, and it forms the right-hand foreground of the present engraving (Canaletto, usually meticulous in such matters, gave the Palazzo Barbarigo only one round-topped window in the last picture instead of the two shown in this and all other versions of the same scene).

As we get nearer the end of the Grand Canal, the scene opens up and now more can be seen of the buildings on the Riva degli Schiavoni in the distance. The church of the Salute on the right, however, is now masked by the Palazzo Dario. On the left the façade of the Palazzo Corner della Ca' Grande, only the side wall of which was visible previously, has now come into view and beyond it begins the long chain of palaces which have now almost all become hotels. The Corner family were one of the richest and most powerful of all Venetian families and owned twelve other palaces in Venice, all bearing their name. They claimed to be de-scendants of the old Roman family Cornelius, hence the "Corneliorum" of the Latin title.

This must have been one of Canaletto's favourite views. He painted his first version, now in the Thyssen Collection in Lugano, Switzerland, possibly as early as 1723, after which there are not less than a dozen versions of the same scene by his own hand and many more from his studio or of his school.

Today the Palazzo Barbarigo, once the home of a family which produced two Doges, a Patriarch of Venice and three cardinals, is covered by nineteenth-century mosaics, having become the property of a glass company. A petrol pump for the use of motor boats stands in the Campo S. Vio. The church of S. Vito, which the Doge and Senate visited yearly to give thanks for the deliverance of Venice from a rising led by Bajamonte Tiepolo in 1310, has been replaced by a tiny votive chapel; pieces of Tiepolo's house, which the Senate ordered to be demolished, have been stuck into its walls. There is also a little Protestant church in the *campo*. The Palazzo Corner della Ca' Grande has become the Prefecture.

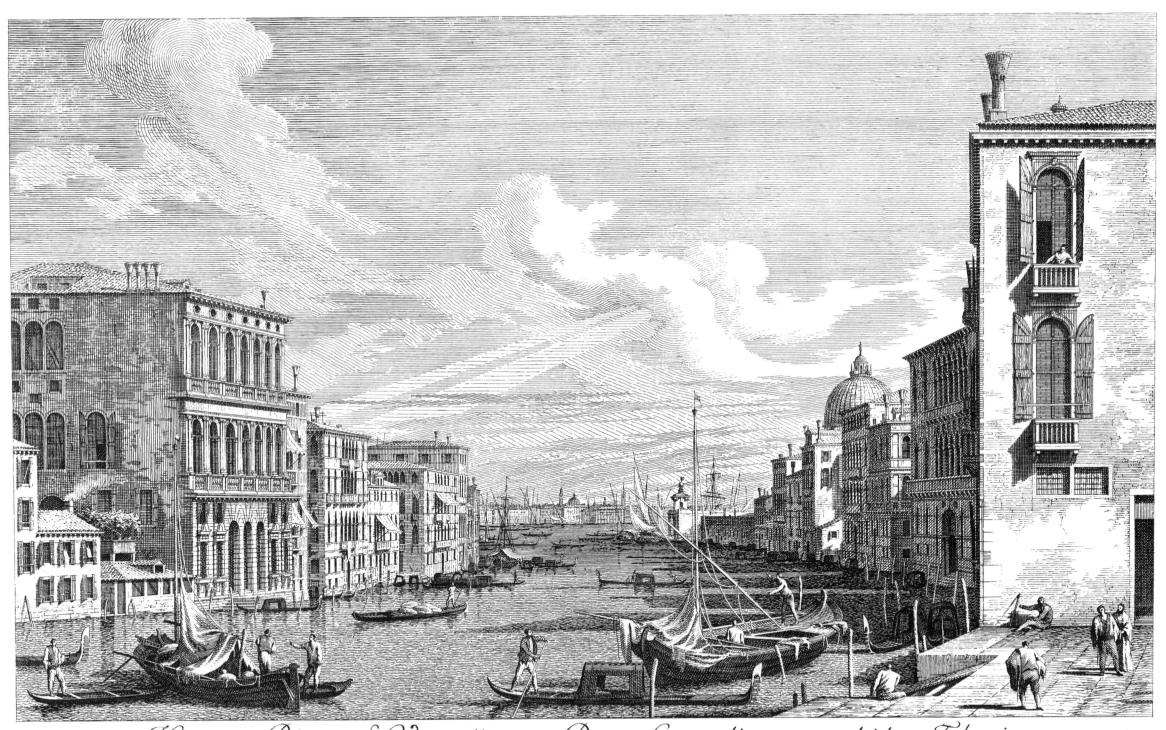

Hinc ex Platea S. Viti, illinc ex Domo Corneliorum, ad idem Telonium.

IV.

Entrance to the Grand Canal: looking East

Now the Grand Canal opens out into the Bacino di S. Marco and all the principal buildings facing the lagoon have come into view. On the left, gradually receding into the distance across the picture, are first the Zecca (mint), with the Ponte della Pescharia beside it, then the adjoining Library built by Jacopo Sansovino and completed by Vincenzo Scamozzi in 1588. The bridge leads to the site of the old fishmarket (out of the picture), hence its name; the Zecca now forms part of the Library. St Mark's Column can then be seen, apparently standing in front of the Doge's Palace, but this is a trick of perspective: the area between the Library and the Palace, called the Piazzetta, cannot be seen and it is in this area that the column stands, together with its companion column dedicated to St. Theodore. Beyond the Doge's Palace is the Prison (compare Fig. 5, p. 6) and between these two buildings runs a *rio* (small canal) spanned by the Bridge of Sighs (not visible) connecting them. The bridge which can be seen is the Ponte della Paglia (straw), first built in 1360; here the Riva degli Schiavoni begins, which extends in front of all the remaining buildings. Some mean buildings follow, now replaced by the new Danieli Hotel, and then the Palazzo Dandolo, since 1822 the main Danieli Hotel. An enlargement of this part of the scene will appear later under Part II, No. 11.

The right-hand side of the picture is dominated by the church of Sta. Maria della Salute, built by Baldassare Longhena. The Senate commissioned the great church in 1630 as a thank offering for the deliverance of the city from the plague of that year. It was completed fifty years later and has remained probably Venice's most celebrated landmark ever since.

Beyond the Salute, as it is generally known, is the Patriarchal Seminary, built by Longhena for the order who had charge of the new church. When Napoleon suppressed the order, the Seminary, which had originally been on this site, returned to it and a collection, still to be seen, was begun of statues and other relics from demolished churches. Beyond the wall is the upper part of the tower of the Dogana di Mare (sea custom house); the figure of Fortune, on a golden ball held up by two Atlases, greets the vast quantity of shipping which passes on both sides of this point. A custom house for merchandise arriving by sea has been on this spot since 1414, the Dogana di Terra, for goods arriving by land, being at the Rialto Bridge; before 1414 all merchandise was examined at S. Biagio, which is just visible in the far distance.

The correspondence with the original painting is almost exact; see Figure 7, page 8.

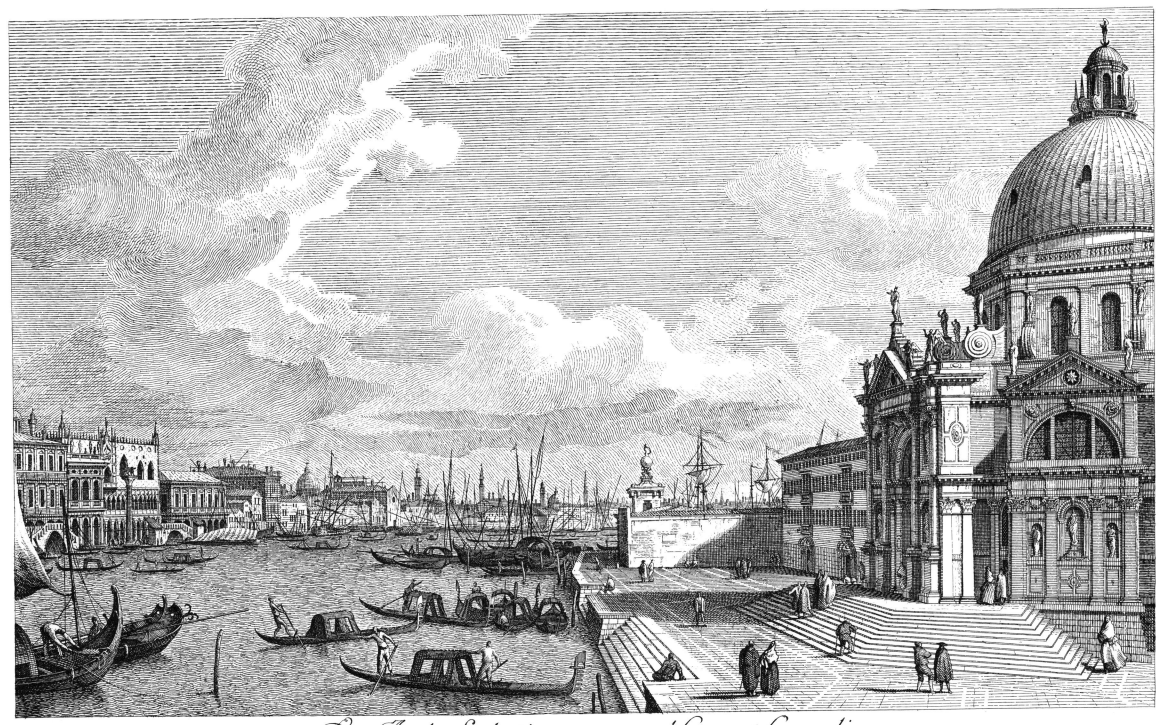

Ex Aede Salutis, usque ad Caput Canalis.

V.

Entrance to the Grand Canal: looking West.

Having travelled down the Grand Canal from the Rialto Bridge to the Salute in five stages, Canaletto now turns and looks up the Canal.

We have already seen most of the buildings on the left from the opposite direction. First is the Dogana di Mare with its golden ball, then the Patriarchal Seminary and the Salute itself with its secondary cupola now visible. The square tower rising above all the palaces belonged to the fifteenth-century Palazzo Venier dalle Torreselle and gave its name, not only to the palace, but also to the branch of the Venier family who built it—even the Donà family who acquired the palace later on became known as Donà dalle Torreselle. It was pulled down in the nineteenth century and the site is now occupied by the American Consulate.

Next to it is another Venier palace, the Palazzo Venier dei Leoni, which is said to have gained its name from a lion which was kept in the garden. It was in a state of decay at the time Canaletto painted his picture, and Girolamo Venier, who died in 1733, directed his heirs to demolish it and build a more worthy palace. The wooden model of the gigantic project can be seen in the Correr Museum, but before the ground floor was completed the work was suspended. It is now the home of Mrs. Peggy Guggenheim and houses her collection of modern art but has never had another floor built on to it. The last building to be seen on the left bank of the Canal is the campanile of the Carità.

The palaces on the right begin with the seventeenth-century Palazzo Tiepolo and end at the Palazzo Corner della Ca' Grande. Almost all have now become hotels. The top of the ancient campanile of S. Samuele can also be seen.

It is likely that this and the preceding picture were painted by Canaletto as pendants and that they are later than the first four we have studied. There is a distinct change in the technique of painting water which Visentini has tried, without complete success, to reproduce. It is, however, interesting to compare his almost straight lines for the water in the earlier engravings with the ruffled surface of Nos. v and vi. The galley, with oars and sails part set, moored beside the custom house is also an unusual feature.

The clouds are less precise in the original painting; see Figure 8, page 8.

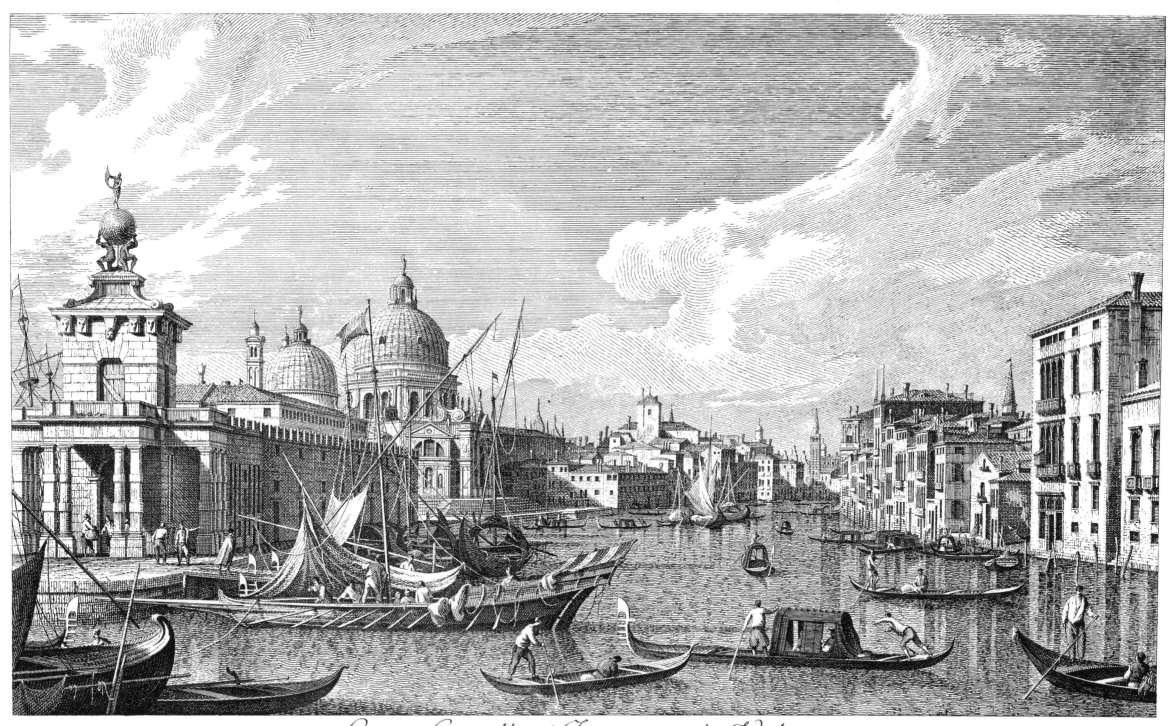

Caput Canalis et Ingressus in Urbem.

VI.

Grand Canal: the Rialto Bridge from the North.

Canaletto has now returned to the Rialto Bridge, the view from which was the subject of the first engraving. The Bridge and the buildings on both sides of it are studied from the north whereas until now we have been only on the southern half of the Grand Canal. As was so often his practice, Canaletto must have made sketches from various nearby viewpoints and built them up into a composition in his studio, for there is no point from which he could have obtained exactly this view.

On the right of the Bridge is the Palazzo dei Camerlenghi, the home of the City Treasurers, an attractive early Renaissance building with an unusual plan dictated by the curve of the Canal at this point. None of the angles facing the Canal is a right angle and Canaletto, like all subsequent artists, has had some difficulty making this apparent in the painting. On the extreme right of the picture are the Fabbriche Vecchie (old buildings of the Rialto) built, like the Palazzo dei Camerlenghi, some sixty years before the present Bridge, and used as public offices. Between the two buildings is the Naranzeria ("orange market," but in fact the fruit and vegetable market) behind which can be seen the back of S. Giacomo di Rialto, probably the oldest church in Venice. There is said to have been a church here in the fifth century and even the present building has eleventh-century parts.

The Latin title refers to "public buildings, along both sides" but the arcaded building on the left of the bridge, now the Post Office, was not in Canaletto's time a public building strictly speaking. It belonged to the Senate but it was known as the Fondaco dei Tedeschi (warehouse of the Germans), and a building for the use of German merchants was being maintained here as early as 1228. In 1505 a fire destroyed the old building and the Senate agreed to replace it, but only with one of brick and plaster without marble facing or other decoration. Two artists were accordingly called in to cover the plain walls with frescoes and so propitious was the moment in the history of Venetian art that Titian was available for one wall and Giorgione for another (the remains of one of his frescoes can be seen in the Academy of Fine Arts). There was little left of their work in Canaletto's time.

There was a pontoon bridge at this point until the thirteenth century, followed by two wooden bridges, the last one a drawbridge with shops. The building of a stone bridge was decided upon in 1524 and many celebrated architects, including Palladio and Michelangelo, submitted designs. Finally, the city's own engineer, Antonio dal Ponte, was appointed in 1588: by this time all the great architects were dead. The Bridge was completed in two years and the superstructure which gives it so ungainly an appearance was added later to enable the shopkeepers to return. Through the arch of the Bridge can be seen the area on the left of our first engraving, including the wooden hut for workmen's tools or the selling of lottery tickets.

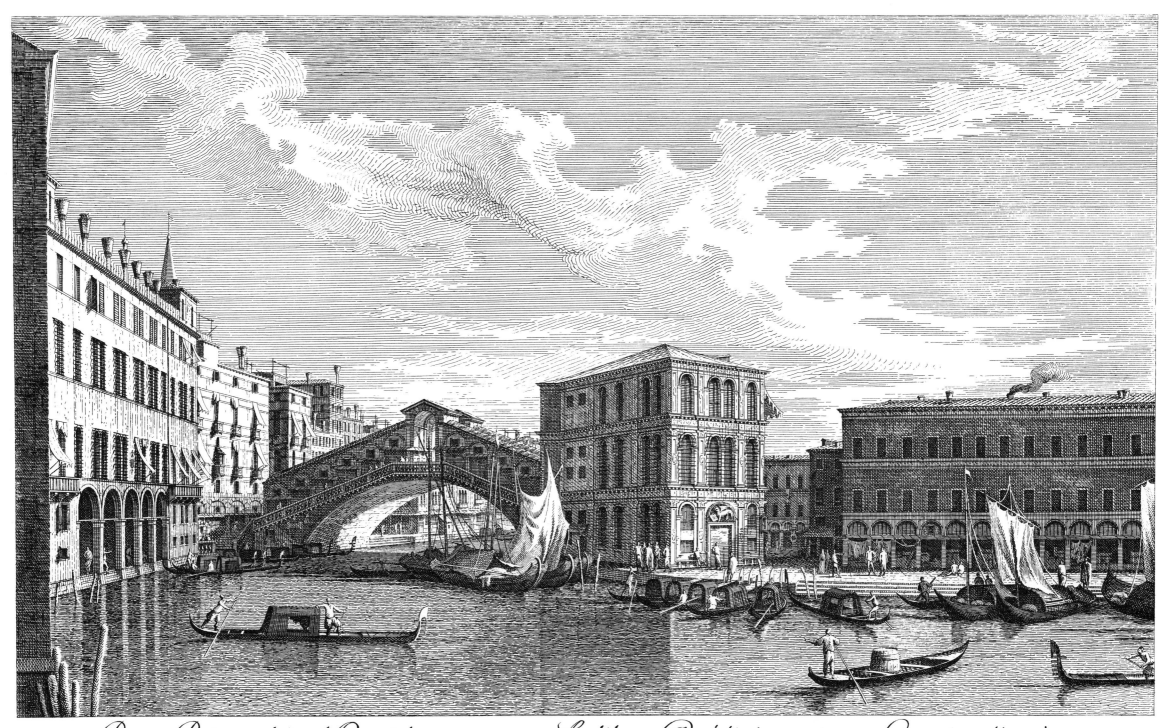

Pons Rivoalti ad Occidentem, cum Aedibus Publicis utrique Lateri adjectis.

VII.

PART ONE / NO. VIII
Grand Canal: looking North from near the Rialto Bridge.

Canaletto is about to show us some scenes on the upper half of the Grand Canal and he starts with the view from the point where steps lead down from the Rialto Bridge to the Fondaco dei Tedeschi. It is the longest straight stretch on the Canal and we can see up as far as the Palazzo Vendramin-Calergi (originally Grimani as in the Latin title) and the top of the campanile of S. Geremia. There is a strong contrast to the bustle and activity we saw from south side of the Bridge in the first engraving. The water of the Canal laps against the ces on the right and at no point is there a *riva* or *fondamenta* along which pedestrians can ʿ.

On the left are the Fabbriche Nuove (new constructions) built by Sansovino in 1555 ...u occupied by the law courts. In front of them is part of the vegetable market and above is the campanile of S. Cassiano with flags flying. Beyond is the Pescheria (fish market) and, where the Canal turns, the Palazzo Pesaro, which will be seen at closer quarters in Part II of this book.

Many of the palaces on the right are of great age and interest. The first to be seen is the Palazzo Dolfin with the campanile of SS. Apostoli above it; there are, though, a number of palaces between this and the Rialto Bridge hidden by the curve of the Canal. Next to the Dolfin palace is the Ca' da Mosto, a thirteenth-century Byzantine palace once inhabited by Alvise da Mosto, the great traveller, but since the sixteenth century, and perhaps much earlier, the Leon Bianco, Venice's most celebrated hotel, which it remained well into the eighteenth century.

Next but one to the Ca' da Mosto is Consul Smith's own house, now known as the Mangilli-Valmarana. It has a simple Venetian Gothic façade and we know that in 1742 this is how it looked (see p. 7). However, the painting from which Visentini made his engraving shows the new façade he had designed for Smith and which was not finished until 1751. When did Canaletto make the alteration, for Smith certainly called him in to make one, as can be seen by close study of the painting at Windsor?* And why did Smith not direct Visentini to alter the engraving, which had been used for the 1735 and 1742 editions, in time for the 1751 edition? Even though the façade may not have been finished in time, Visentini knew how it would appear for he had designed it himself. It is unlikely that we shall ever know the answers.

Canaletto "rearranged" his scene more than usual for this picture. The campanile of SS. Apostoli is not visible unless one ascends the Rialto Bridge and most of the buildings of the left bank then disappear. It should be noted that between Smith's Mangilli-Valmarana palace and its neighbour which adjoins the Ca' da Mosto, there runs a *rio* which is not visible in the picture.

The clouds in the engraving differ from those in the original painting.

* See *Later Italian Pictures in the Royal Collection* (Phaidon, 1964, p. 59), by Michael Levey, who made this discovery.

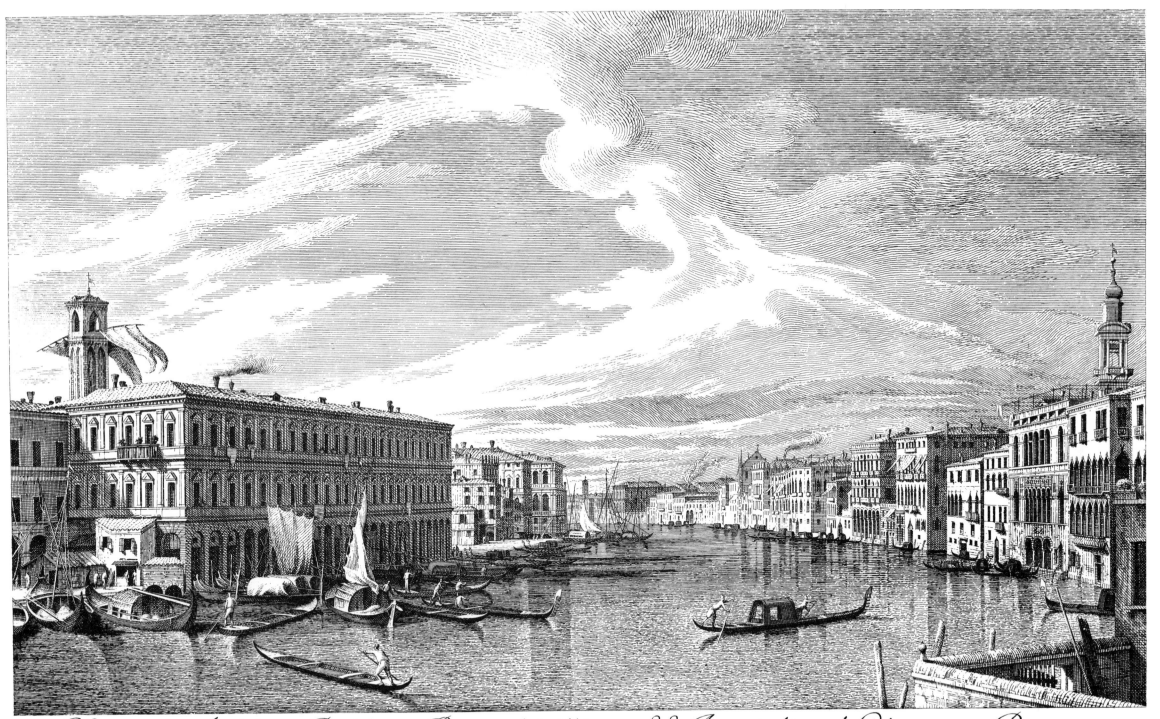

Hinc ab Aedibus Publicis Rivoalti, illinc a SS. Apostolis ad Grimanam Domum . VIII.

Grand Canal: looking North-West from the Palazzo Vendramin-Calergi to S. Geremia and the Palazzo Flangini.

The Palazzo Vendramin-Calergi, which appeared in the far distance of the last engraving, is now in the right-hand foreground (as seen, in fact, from near the left bank of the Canal, the buildings on the left being shown as they would be seen from near the right bank). The palace was built for the Loredan family and has had many owners including the Calergi, Grimani and Vendramin families, all illustrious Venetian names; the Duchess of Berry maintained her nineteenth-century *salon* there and Richard Wagner died in it. It was Venice's first Renaissance palace, having been begun in the 1480's by Mauro Coducci and finished in 1509 by the Lombardi family, who did much work in the city. It is now used as the Municipal Winter Casino.

More of the campanile of S. Geremia can now be seen than in the preceding picture, and the church itself has come into view; curiously enough the window in its side wall, clearly shown in the engraving and in the Correr and British Museum drawings, does not appear in Canaletto's painting. It is by this church that the Cannaregio ("Canalem Regium" of the Latin title) enters the Grand Canal. In the far distance is the still unfinished Palazzo Flangini.

The first of the two palaces with obelisks on the left is the Palazzo Tron ("Thronorum" of the Latin title), owned by a typical family of the Venetian merchant aristocracy, and the second is the Belloni-Battagia; the Bellonis were traceable back to the sixth century in Dalmatia and one of them married a Battagia in 1659. The palace was built by Longhena of Salute fame.

Beyond the two obelisked palaces are two with crenellation, the first being the Depositi del Megio, the Public Granaries, now a school, and the second the venerable Fondaco dei Turchi. This building was five hundred years old in Canaletto's time, having been built originally as a merchant's home with warehouse space on the ground floor and arcades for the passage of barges. In 1381 it was bought by the Senate and used, first by distinguished visitors such as the Duke of Ferrara and Pope Clement VII, then as a warehouse for the Turkish merchants, just as the Fondaco dei Tedeschi was used by the Germans. In the nineteenth century it fell into decay and was used as a tobacco warehouse, to the dismay of John Ruskin, who wrote, "It is a ghastly ruin; whatever is venerable or sad in its wreck being disguised by attempts to put it to present uses of the basest kind." In the end it had to be taken down altogether and a "reconstruction" was erected on its site which is now the Natural History Museum.

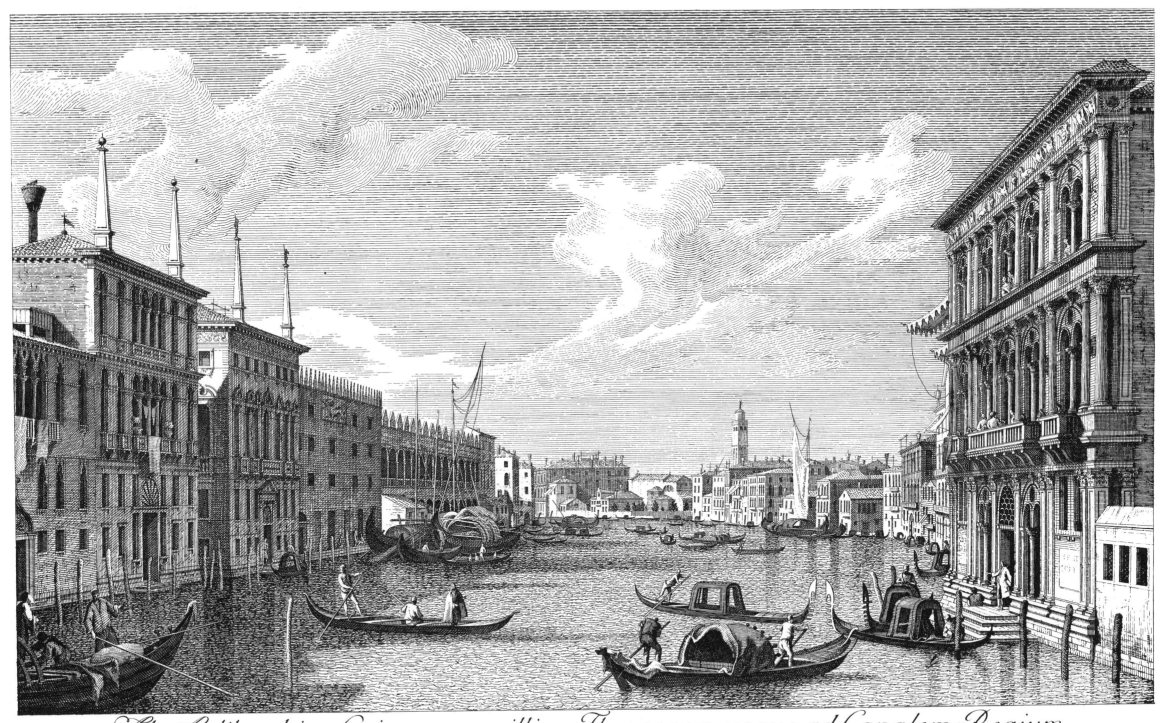

Ab Aedibus hinc Grimanorum, illinc Thronorum usque ad Canalem Regium.

IX.

PART ONE / NO. X
Grand Canal: S. Geremia and the Entrance to the Cannaregio.

For the first and only time in this series Canaletto now looks across the Grand Canal instead of looking up or down it. It is where the Grand Canal is joined by the Cannaregio, the only waterway in the city of Venice to be called a canal other than the Grand Canal itself: any other is called a *rio* (brook). In Canaletto's time, and until the building of the railway bridge linking Venice to the mainland in 1846, this was the point at which most visitors arrived in the city by ferry from the last mainland town of Mestre. Some of Venice's greatest palaces line the banks of the Cannaregio; the tall buildings in the centre background are those of the old Ghetto, still standing.

On the left is the church of S. Geremia; the façade was destroyed when the Austrians bombarded Venice in 1849 following the Manin rising against them of 1848–9, and the present one was built in 1871. The campanile, although not the belfry, is one of the oldest in Venice, dating probably from the twelfth century.

Beside the campanile, with a façade on the Grand Canal, another on the Cannaregio and a third on the Campo S. Geremia, is the Palazzo Labia, recently completed when the picture was painted but as yet without Tiepolo's frescoes, now its greatest glory. The Labia family had bought their position as noblemen only in 1645 at enormous cost, even to them. They had vast riches, which they paraded ostentatiously, and it was said to be their custom to throw their gold plates into the Canal after a banquet, the head of the family crying, "Le abia, o non le abia, sarò sempre Labia" (Whether I have them or not, I shall still be Labia). The palace was restored in the 1950's, after becoming derelict, and was later sold to the Italian Broadcasting Company.

On the quay will be seen a balustrade and a statue (of S. Giovanni Nepomuceno) but these do not appear in the 1735 edition of this book. Since they were erected only in 1742, this is as would be expected. Visentini's drawing for the engraving in the Correr Museum series (but not the drawing in the British Museum series) has had the balustrade and statue added later, doubtless for the 1742 edition of the book. It may not be surprising that Smith should have had Visentini bring his engraving up to date. It is extremely surprising, though, that Canaletto's painting at Windsor contains the new features, although it must have been painted before the 1735 edition of the book. Evidently Smith demanded the addition to his painting, as in the case of his own house in Part I, No. VIII—but in the latter case the engraving was never altered. As can be seen in Fig. 2, p. 5, Canaletto never altered his drawing of the subject (from a slightly lower angle), which was also in Smith's collection.

The engraving differs from the original painting in the clouds and also as noted above.

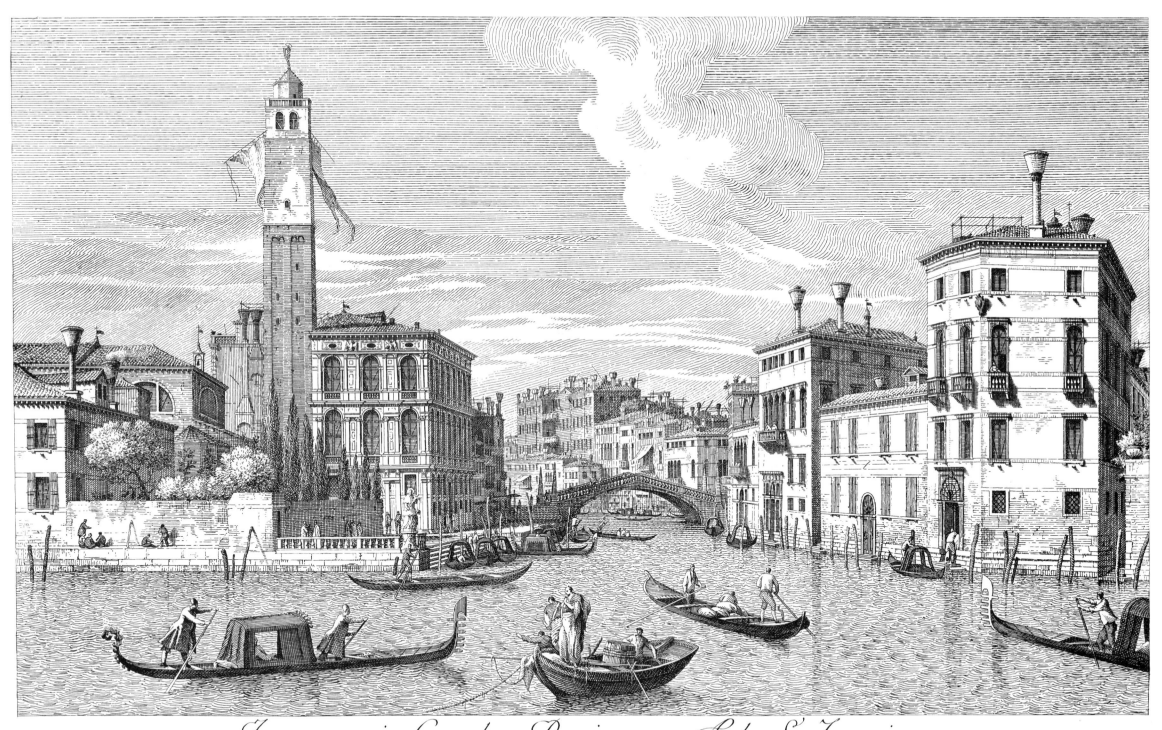

Ingressus in Canalem Regium ex Aede S.ᵗ Ieremiae.

X.

Grand Canal: looking South-West from the Chiesa degli Scalzi to the Fondamenta della Croce, with S. Simeone Piccolo.

We are near the end of the Grand Canal, which can be seen in the far distance. On the right is the church of the Scalzi (the barefooted friars, "Discalceatorum" of the Latin title), designed by Longhena and completed in 1689 after his death, when it was dedicated to Sta. Maria of Nazareth. Beyond it are the palaces and convents and the church of Sta. Lucia, which were all demolished for the building of the railway station in 1861.

Next to the two houses on the extreme left, both still standing, comes the church of S. Simeone Piccolo ("Minore" of the Latin title), built in imitation of the Pantheon in Rome. Although the church had been founded in the ninth century, the present building had only just been completed when Canaletto's picture was painted. The workmen's hut can be seen still standing by the steps and there are blocks of stone not yet used. A drawing by Canaletto at Windsor shows the work at an earlier stage, and a painting by him in the National Gallery, London, shows the same scene as the present picture after the steps had been completed.

The building with the pitched roof in the mid-distance is the church of Sta. Croce, and beyond it was a *tintoria*, or dyeing establishment (the "Fullonium" of the Latin title).

Very little of Canaletto's scene remains today except the two principal churches shown. In the 1930's a stone bridge was built opposite the church of the Scalzi to replace an iron one erected in the nineteenth century. Although of the same proportions as the Accademia Bridge, and by the same designer, it appears far more graceful. The bridge and the railway station now dominate the scene and it is hard to realise that this was ever a fashionable quarter of the city.

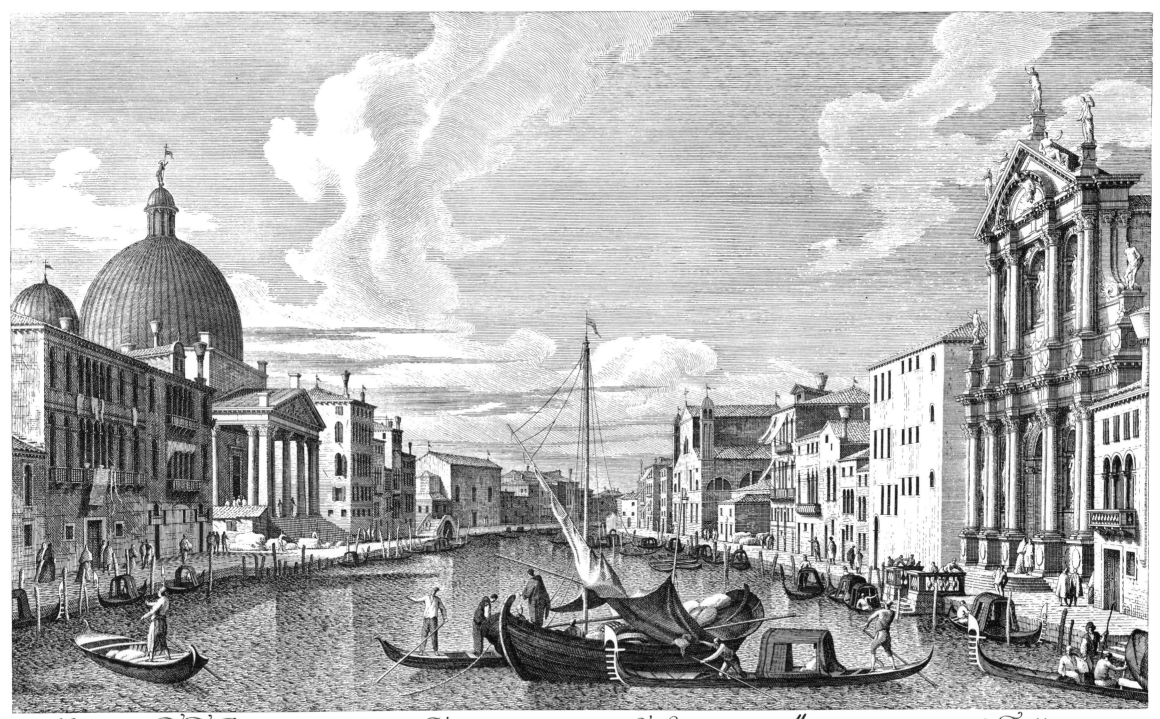

Hinc ex F.F. Discalceatorum Templo, illinc ex S.' Simeone Minore usque ad Fullonium. XI.

Canale di Sta. Chiara: looking North-West from the Fondamenta della Croce to the Lagoon.

For the last of the first series of Grand Canal pictures Canaletto has gone to the point where it enters the lagoon. In the mid-distance is the island of Sta. Chiara with its church and convent, from which this stretch of water received its name. In the distance are the hills of the mainland and on the right the wall of the convent of Corpus Domini.

On the left is a row of houses, the second (complete) one bearing an oval sign over the door. This was the home or office of the English Resident in Venice, who was senior in rank to the English Consul. Canaletto painted another version of this scene, now in Milan, which was engraved by Henry Fletcher and published in England in 1739 by Joseph Baudin. The engraving carries the strange title *A View of ye Continent from ye Bottom of ye great Canal at Venice* and in this version an important personage has landed from his gondola outside the British Resident's house and is being received by a row of bowing figures. The house has been described as belonging to Joseph Smith but there is no foundation at all for this; on the back of the Milan version there is a label in an eighteenth-century English hand saying that the personage represented is Colonel Burgess, English Resident in Venice, and that

"the genuine old and famous Canaletto painted the picture about 1730." One Elizaeus Burges or Burgess did hold the post between 1719 and 1722 and again from 1728 until his death in 1736.

The Latin title describes the viewpoint as "Ex Fullonio," from the dyeworks, and there is an old palace, now the Hotel Sta. Chiara, which is recorded as having been a club-house in 1661 and afterwards, until the fall of the Republic in 1797, a dyeing establishment.

Today's visitor to Venice will find it hard to identify the spot although this is where those arriving by car leave their vehicle and take to the water. Where the dog in the foreground stands there is now a canal leading past the Piazzale Roma, always congested with cars and buses. Only the curve of the canal and the English Resident's house, now the office of the Italian Automobile Association, make identification possible. Whoever wrote the titles on the Correr Museum drawings in the eighteenth century, himself evidently found some difficulty, for he called the drawing *Veduta delle Fondamente di Canalregio*.

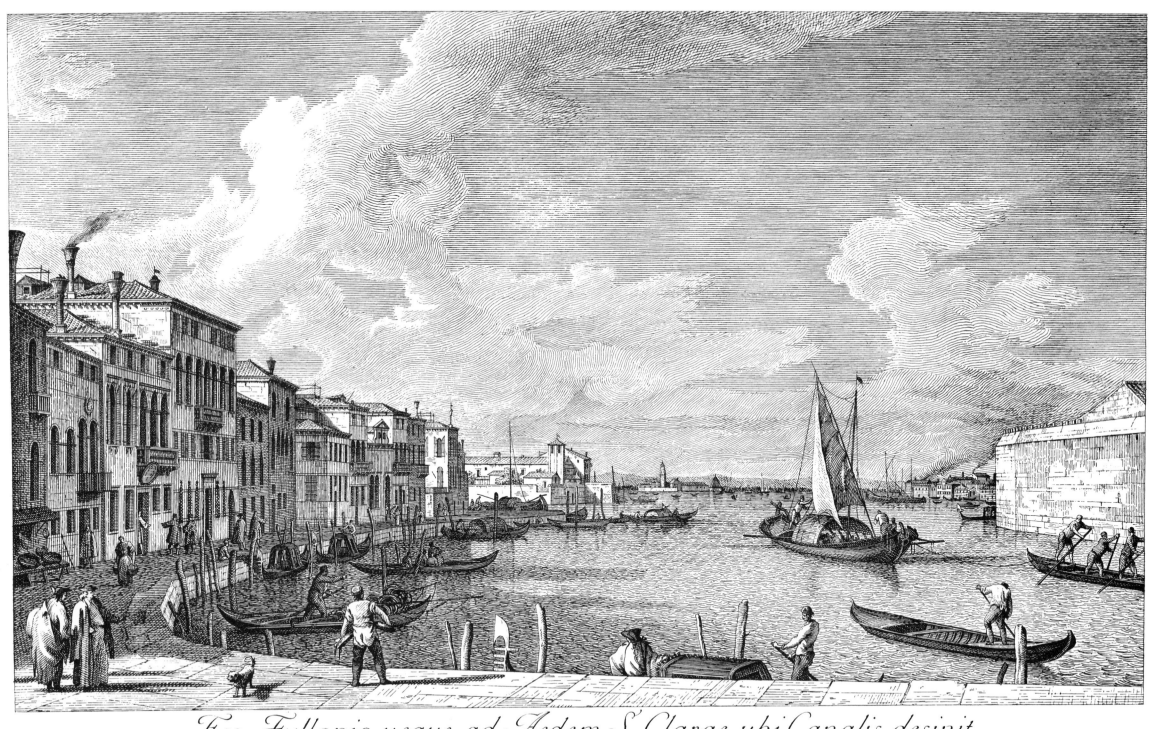

Ex Fullonio usque ad Ædem S. Claræ ubi Canalis desinit.

XII.

PART ONE / NO. XIII

A Regatta on the Grand Canal.

This and the next picture may well have been engraved and included in the first edition of the book as afterthoughts. The original paintings are considerably larger than the others and each shows a ceremonial occasion, very different from the everyday life of the Grand Canal depicted in the first twelve pictures.

We have returned to the Palazzo Foscari for its viewpoint and look up to the Rialto Bridge, half of which can be seen in the far distance. The scene is in the reverse direction to that of the first in the series. On the left is the Palazzo Balbi and beyond it the Palazzo Dolfin, on which a special stand has been erected for spectators. Both sides of the Canal are lined with Venice's greatest palaces; on almost all of them decorations have been put out for the occasion.

On the extreme left is an elaborate temporary structure called the *macchina* which was erected where the Rio di Ca' Foscari joins the Grand Canal; this *rio* now joins a new canal which provides a short cut to the Piazzale Roma and the railway station. The course for the gondoliers' race (the "Nauticum Certamen" both of this engraving and of the *Prospectus* title-page) which is in progress ran from the extreme east of the city, up to the spot shown in the last picture, and back to the *macchina*, where the prizes were given. Elaborate decorated gondolas and a *bissone* (eight-oared barge) carry spectators, and the arms of Doge Carlo Ruzzini on the *macchina* indicate that the regatta took place during his reign—1732 to 1735.

This is the earliest of more than a dozen versions of the same scene by Canaletto or his studio, including two in the National Gallery, London, but in them Canaletto merely follows an earlier painting by Luca Carlevaris which showed the regatta held in 1709 in honour of the King of Denmark. The King may have taken the picture back to Denmark, where it remains today, but Canaletto must have seen either the original or copies which are now in Rome and Leningrad. Just as Canaletto followed Carlevaris, Francesco Guardi followed Canaletto with an almost complete copy of the painting, now in the Gulbenkian Collection in Lisbon.

The Palazzo Balbi on the extreme left was built 1582–90 for Nicolò Balbi, who is said to have refused to sleep under a roof until his palace was finished, with the result that he moored a barge opposite the site, in which he lived with his family until death overtook him before the work was complete. It was from a later member of the Balbi family that Smith leased, and later bought, the palace on the Grand Canal now known as Mangilli-Valmarana. The Palazzo Balbi and its neighbours are often referred to as being *in volta de canal* from the great turn (*volta*) the Canal takes at this point.

The original painting measures $30\frac{1}{4} \times 49\frac{1}{2}$ inches; see Figure 9, page 8.

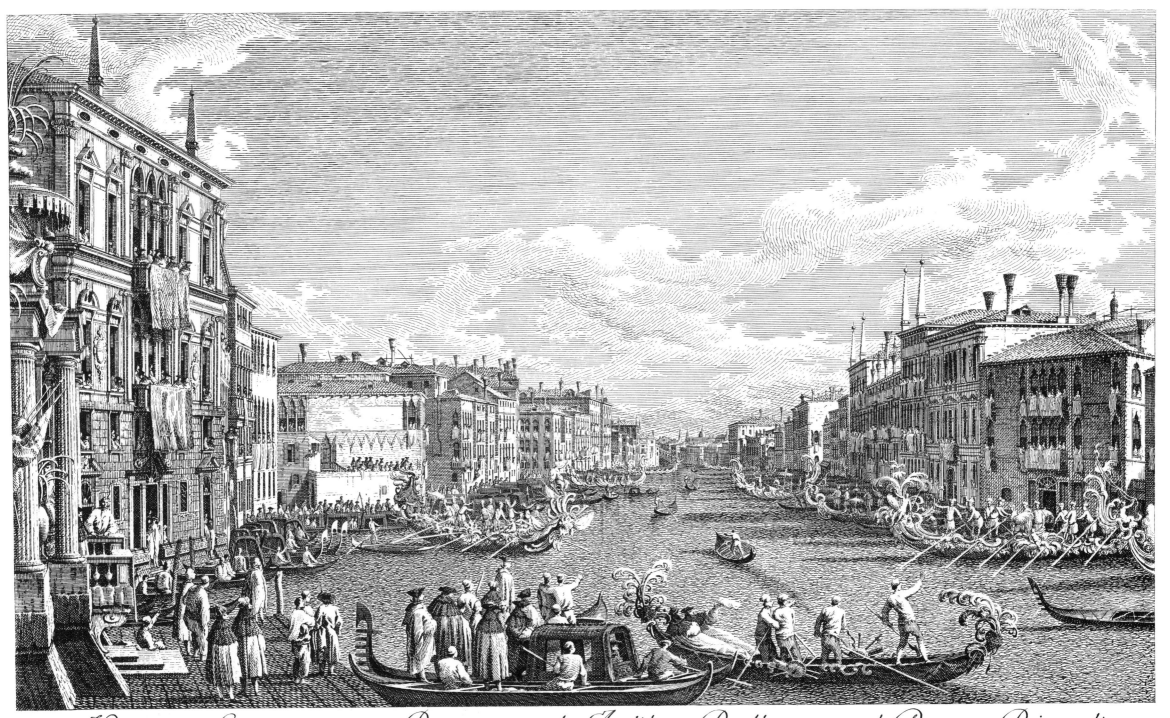

Nauticum Certamen cum Prospectu ab Aedibus Balborum, ad Pontem Rivoalti. XIII.

The Bucintoro returning to the Molo on Ascension Day.

We are in the Bacino di S. Marco, the Pool of St Mark, facing the Molo, the mole or quay which houses the great constellation of buildings we saw at a distance from the entrance to the Grand Canal in engraving No. v. Now, however, the Piazzetta has become visible, with the Columns of St Theodore and St Mark near the water's edge, the south side of St Mark's Cathedral in the right background and the Clock Tower to its left. Behind Sansovino's Library, on the left side of the Piazzetta, is the campanile of St Mark. It has stood there only since 1912 but its predecessor, of which it is an exact copy, stood for close on a thousand years before collapsing in 1902. It was here on the Molo that the great ceremonies took place, and the great visitors were welcomed by the Doge and Senate, throughout the history of Venice.

It is Ascension Day and the Doge has just returned from the ceremony of the Marriage of the Sea. His Bucintoro (state barge) has been brought from the Arsenal to the Molo, where he embarked with senators and notabilities and was rowed to the Porto di Lido, where the waters of the Adriatic enter the lagoon. There he cast a gold ring into the sea in commemoration of a naval victory over Dalmatia in about 990, declaring that Venice took the sea in marriage. Now he has returned to the Molo, where he is about to disembark and attend more ceremonies, finishing with a banquet in the evening. Booths and stalls can be seen on the Piazzetta as part of a market held here on Ascension Day. This was the "Nundinae" of the Latin title and of the *Prospectus* title-page; the attention thus drawn to an apparently unimportant part of the picture is rather surprising.

This Bucintoro had only just been built when Canaletto painted the scene, although it had had a number of predecessors. It was hardly used at all except for the Ascension Day ceremony and was expected to last for a hundred years. No new Bucintoro had been built when the Republic fell to Napoleon in 1797.

There are even more versions of this scene by Canaletto and his studio than of the preceding Regatta on the Grand Canal, at least eight of them wholly by Canaletto. In one of them, now in Milan, the threatened collision between the two gondoliers in the left foreground of the present picture has actually taken place. Other versions vary the viewpoint slightly and also the disposition of the craft in the Bacino. Some version of the Ascension Day ceremony, though, whether by the master or his followers, seems to have been an almost essential requirement for the eighteenth-century visitor to Venice to take home if he could afford it.

It was in all ways a suitable picture for Smith to include as the last of Visentini's engravings in the first edition of his *Prospectus*.

The original painting measures $30\frac{1}{4} \times 49\frac{1}{2}$ inches. The engraving corresponds closely, but not exactly, to the painting.

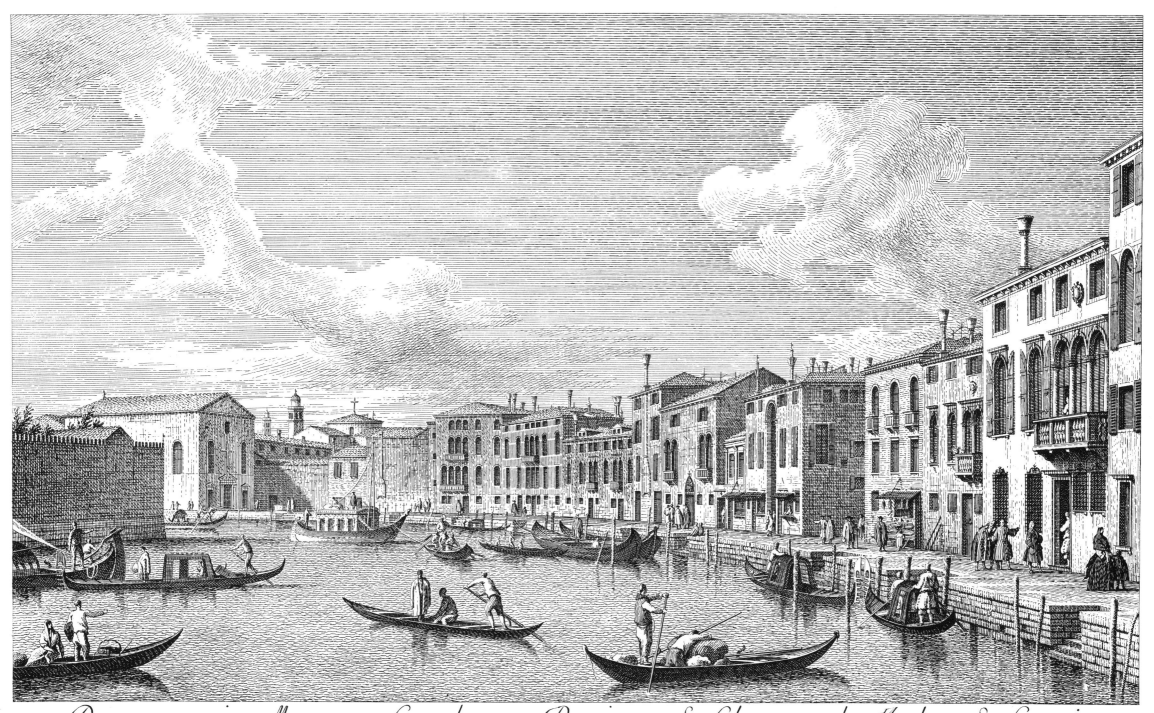

Prospectus in Magnum Canalem e Regione S. Clarae ad Aedem S. Crucis 1.

Grand Canal: looking North-East from Sta. Croce to S. Geremia.

To make his drawings for this painting Canaletto had only to turn his eyes to the right from the position he had adopted for his scene showing the English Resident's house, Part I, No. XII; like that picture, this one was also done "ex Fullonio," from the dyeworks. The façade of the church of Sta. Croce was prominent on the left of the last engraving, No. 1; now it is even more prominent on the right. The façade must, from its appearance, have been relatively new as the building itself was already an ancient one. It was demolished in 1810 and a granite column with a Byzantine capital from the church was built into the wall of the Papadopoli Gardens; these occupy much of the area in this district today including that on which Sta. Croce (and the wall shown in the last engraving) then stood. Sta. Croce gave its name to one of the six *sestieri* into which Venice is still divided and which are still used, with the addition only of a house number, for postal addresses throughout the city.

In the middle distance we see the dome of S. Simeone Piccolo with the church of the Scalzi opposite. We saw them in the reverse direction in Part I, No. XI, which also showed Sta. Croce in the distance. All the buildings on the left as far as the Scalzi have been demolished to make way for the railway station. In the far distance is the top of the campanile of S. Geremia (Part I, No. X). In the left foreground, and curiously enough in exactly the same position as it occupied in the previous picture, is the *burchiello*. It was then being towed towards Padua: now it is on the return journey. Apparently it was always towed while in the Grand Canal.

The painting from which Visentini made this engraving was one of a group of twenty-one, eleven of them showing scenes on the Grand Canal, said to have been bought in Venice by a Duke of Buckingham. Their origin is, however, obscure and all that is known for certain is that they descended to Sir Robert Grenville Harvey, who died in 1931 and whose trustees sold them in 1957; they are now dispersed. As many as nine of the twenty-four paintings chosen for the second and third parts of this book came from the same group and two more paintings from the group were engraved and obviously intended for the book but not in the end included. Drawings for all these are in the Correr Museum, Venice, and the British Museum, London (see pp. 4–5). (The Correr Museum drawing for the present engraving is not missing, as stated in Constable: it is the next one which is missing.) All this points strongly to the assumption that Joseph Smith once owned the so-called Buckingham, or Harvey, series.

Original painting: formerly Sir Robert Grenville Harvey.

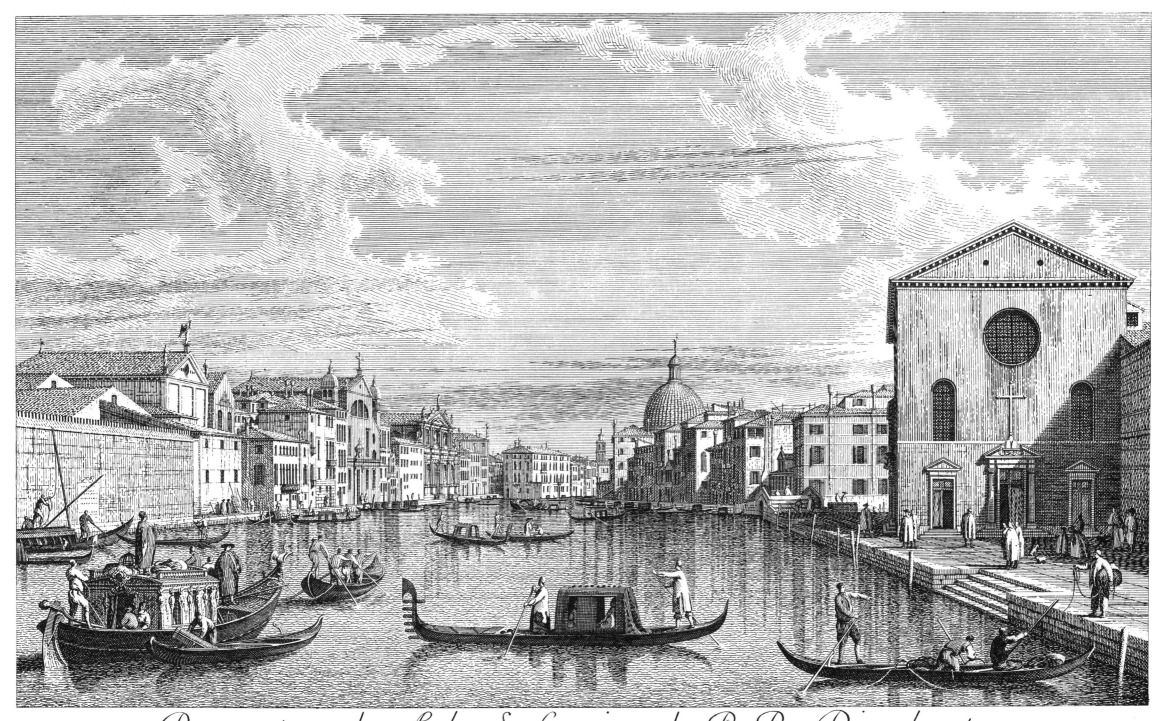

Prospectus ab Aede S. Crucis ad P. P. Discalceatos.

2.

Grand Canal: looking East from the Palazzo Flangini to S. Marcuola.

The distant background of the last picture has become the foreground of the present one; the top of the campanile of S. Geremia has become masked by the Palazzo Flangini on the left but the cupola of the church itself appears to be resting on the next house, the Scuola dei Morti. The Grand Canal has turned and here runs eastward. Next to the Scuola dei Morti (one of the few buildings seriously damaged by Austrian bombing in the 1848–9 rising) is the house of the Canon of S. Geremia, part of which was seen on the left of Part I, No. x. We then see the quay (without the balustrade referred to under that engraving) but it is not easy to realize that beyond the quay is the wide entrance to the Cannaregio. On the far side of the quay is the unfinished Palazzo Querini followed by a long series of palaces and then part of the Campo S. Marcuola; the church of S. Marcuola is not visible. The last building on the left bank is part of the Palazzo Vendramin-Calergi. The projecting side wall on the right belongs to the Palazzo Bembo, demolished in the eighteenth century.

The Flangini family, who built the palace on the left, came from Cyprus and bought their way into the Venetian nobility in the seventeenth century, when the Republic made this possible in order to pay for the war against the Turks. It seems that the palace was never finished but there is a legend that it was once twice its present size and that one of two brothers who had jointly inherited it demolished his half in a fit of jealousy.

Constable gives a painting, then belonging to Miss Tessie Jones, now in the Minnea-polis Institute of Arts, as the original of this engraving in spite of its being considerably larger than the other paintings engraved by Visentini. In fact, the original is almost certainly a painting now in the Wrightsman Collection (reproduced in Fig. 10, p. 8). Four other pictures in this collection are known to have come from the Harvey series (including the one engraved in Part III, No. vi) but the painting under discussion was bought separately. The Harvey group originally consisted of twenty-one but only twenty were catalogued by Constable and dispersed by the trustees in 1957; one had become detached some years previously and forgotten. The Wrightsman painting is the same size as all those in the Harvey group and corresponds exctly with Visentini's engraving. There can be little doubt that it is the missing member of the Harvey series and that it has fortuitously joined the four known members of the series in the same collection.

Visentini's drawing for this engraving is missing from the Correr group (although included in the British Museum album); could it have been extracted for the addition of the new statue and balustrade referred to under Part I, No. x and never returned?

Original painting: probably Mr and Mrs Charles Wrightsman (formerly Harvey series; see above and see Figure 10, page 8).

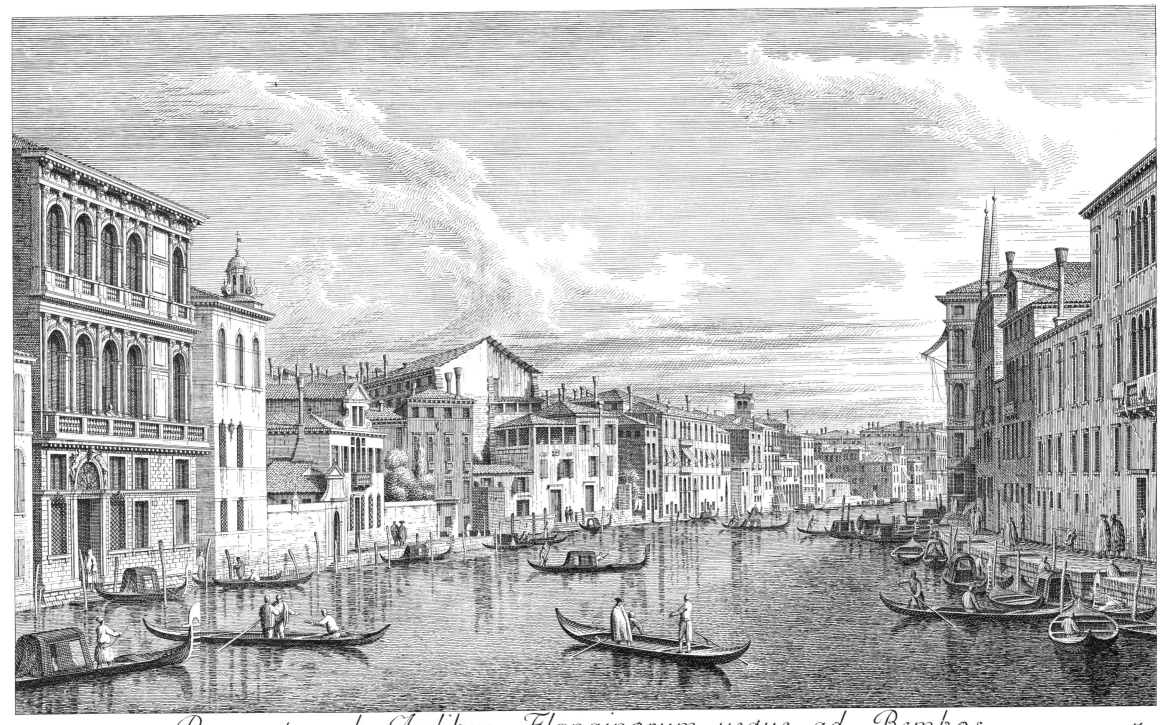

Prospectus ab Aedibus Flanginorum usque ad Bembos. 3.

Grand Canal: looking East from the Palazzo Bembo to the Palazzo Vendramin-Calergi.

This was a somewhat surprising choice for the next engraving; it is but a hundred yards or so farther down the Grand Canal from the previous one and many of the same palaces appear in both. On the right, the Canal façade of the Palazzo Bembo has now come into view and in front of it are the poles for the gondola ferry which crossed to S. Geremia (as can be seen on the left of the last engraving). The Riva di S. Biasio ends at this point; one could walk beside the Grand Canal along it for some distance but would then have to turn inland before joining the long *riva* which then extends to the "head" of the Canal at Sta. Chiara. Beyond the Palazzo Bembo, with the sun shining on its side wall, is the Gothic Palazzo Giovanelli and beyond this, although scaracely visible, is the house which became the home of Teodoro Correr (1750–1830) whose collection was the nucleus of the Correr Museum; the museum itself was in this house until 1880.

On the extreme left is the quay beside the Cannaregio on which were later to be erected the statue and balustrade which have proved of such interest. As can be seen by comparison with the last engraving, Canaletto has cut off the end of the quay in an uncharacteristic way. Above it is part of the unfinished Palazzo Querini and then the small house with the loggia, seen in the last engraving, both on the far side of the Cannaregio. A series of palaces leads from here to the great Palazzo Vendramin-Calergi. As has been mentioned under Part I, No. IX, it was the first Renaissance palace to be built in Venice, having been completed for Andrea Loredan about 1509. A century later it was the property of the Calergi family, who later became Grimani-Calergi through marriage, and in 1759 it passed to another branch of the family called Vendramin; from the Latin title, however, it was evidently already known as "Vendramin" by 1742.

There is a sketch-book of Canaletto's in the Academy of Fine Arts in Venice, four pages of which contain sketches for this picture. In these Canaletto refers to the palace as "Ca Grim¹" and "Casa Grimani"; he also notes that there is a "trageto" (ferry) by the Palazzo Bembo, and has made colour notes beside many of the buildings.

The Woburn Abbey series consists of twenty-four paintings but nothing is known of their origin. One other (Part III, No. VII) corresponds exactly with a Visentini engraving and a third (Part II, No. 10) very closely.

Original painting: The Duke of Bedford, Woburn Abbey, England; $17\frac{5}{8} \times 29\frac{3}{4}$ inches.

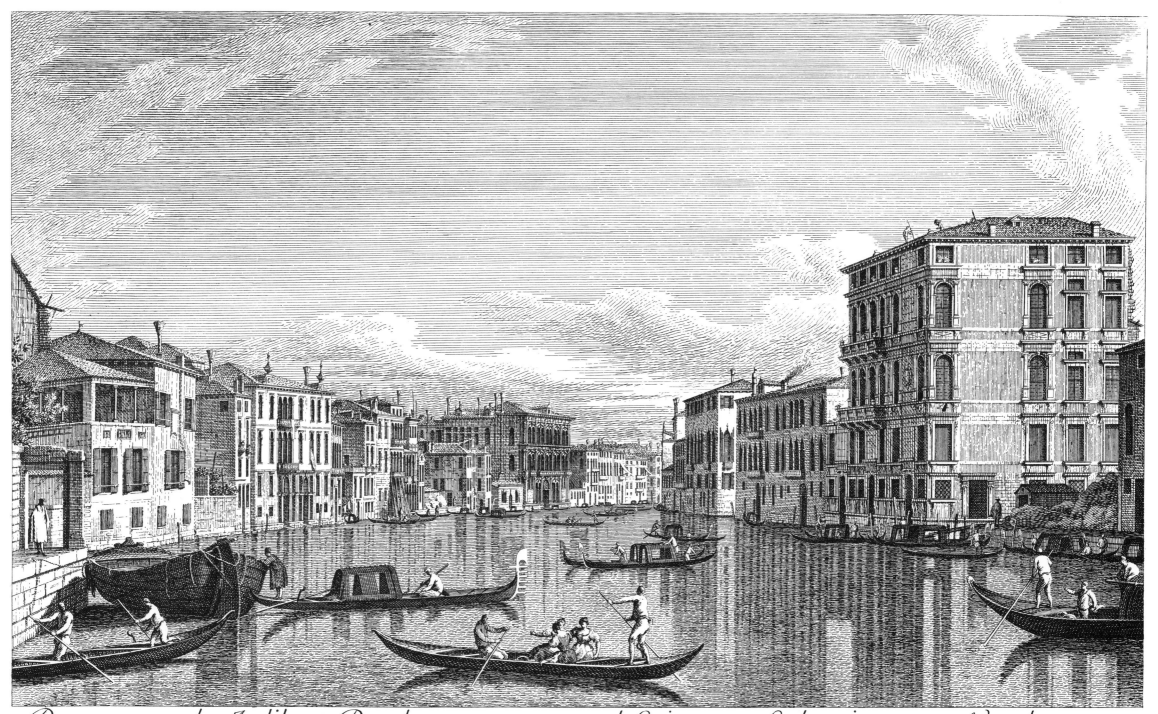

Prospectus ab Aedibus Bemborum usque ad Grimanos Calergios nunc Vendramenos.

4.

Grand Canal: looking South-East from S. Stae to the Fabbriche Nuove di Rialto.

The long row of palaces on the left begins with the Palazzo Barbarigo, which would have been just out of sight in the far distance of the last engraving. Canaletto has moved down the Grand Canal to a point from which he can see along it as far as the Fabbriche Nuove ("new buildings," the "Substructiones" of the Latin title), which are beside the Rialto Bridge. He shows us tantalizingly little of the superb palaces on the left—we saw them more clearly looking in the reverse direction on the right-hand side of Part I, No. VIII. The high-masted sailing barge in the mid-distance stands beside the Ca' d'Oro, perhaps the brightest jewel of the whole Canal, but we see no more of it than we saw in the view from the Rialto Bridge. Nearer to us are two palaces whose side walls are in sunlight. The first, called Boldù, belonged to the Contarini family, who provided eight Doges (one of the family assisted at the election of the first Doge in 697) and owned twenty-two palaces bearing their name in Venice. The more distant is the Palazzo Fontana, which belonged to the Rezzonico family; Pope Clement XIII (Rezzonico) was born here in 1693.

On the right is the church of S. Eustachio, always known as S. Stae. The Baroque façade is covered with marble decorations and statues and was added to the church in 1709; John Ruskin considered it "ridiculous" and he must often have looked out on it, as his greatest friend in Venice, Rawdon Brown, lived opposite in the Palazzo Gussoni, just visible on the left. The two great Renaissance palaces beyond S. Stae, in the mid-distance, are the Pesaro, which will be seen more closely in the next engraving, and the Corner della Regina. The latter was built on the site of a palace in which Caterina Cornaro was born. She married the King of Cyprus and after his death was persuaded, with great difficulty, to cede the island to her native Republic of Venice. The Palazzo Foscarini, the first palace beyond S. Stae, was the birthplace of Marco Foscarini, who became Doge in Canaletto's lifetime; it was here that King Charles of Denmark stayed in 1709, when the Regatta on the Grand Canal in his honour took place and was commemorated in Carlevaris's painting (see Part I, No. XIII).

Visentini's engraving corresponds closely with a painting in the Harvey group in viewpoint and lighting but the boats and the proportions of the buildings are different; this painting could not have been the original of the engraving. A painting which was formerly in the Minneapolis Institute of Arts is much closer and probably the original; it is now in Baron Thyssen's collection in Lugano, which also contains Canaletto's two earliest view paintings.

Original painting: Thyssen Bornemisza Collection, Lugano, Switzerland.

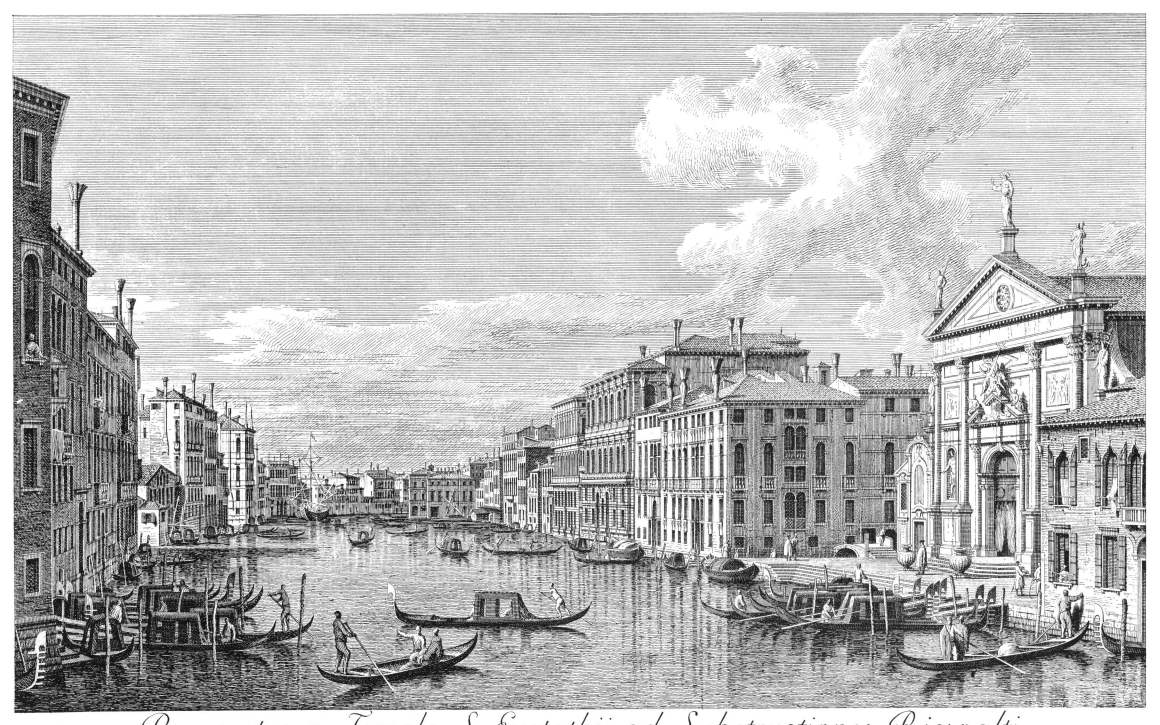

Prospectus a Templo S. Eustathii ad Substructiones Rivoalti.

5.

Grand Canal: looking North-West from the Palazzo Pesaro to S. Marcuola.

The first six engravings of Part II follow the pattern set in Part I by proceeding in five stages down the Canal from Sta. Chiara and, for the sixth, turning in the reverse direction. Logically, this engraving might have been placed between Nos. VIII and IX of Part I, as the viewpoint is between those two.

The Palazzo Pesaro, more generally called the Ca' Pesaro, dominates the left of the picture and is followed by the Palazzo Foscarini (now demolished) and then a small *campo* in which stands the church of S. Stae; the church is not visible but the pinnacle of its façade can be seen above the building between the Pesaro and Foscarini palaces. Perhaps the largest of all the Grand Canal palaces, the Ca' Pesaro was designed by Baldassare Longhena, the Republic's greatest seventeenth-century architect, who designed the church of the Salute. It was begun with a magnificent inner courtyard which was completed in 1663, and the Grand Canal façade had reached the second floor by 1679. Three years later Longhena died and the work was stopped for more than twenty years. Another architect, Antonio Gaspare, completed it by 1710. Leonardo Pesaro, for whom the palace was built, occupied the high position of Procurator of S. Marco and his family were still occupying the palace when the Republic fell in 1797; the last Doge, Ludovico Manin, took refuge with them when he was deposed. The palace was later given to the city of Venice and is now the Modern Art Gallery.

On the right we see a series of sixteenth and seventeenth-century palaces; the last before the tall Vendramin-Calergi, in the mid-distance, is the Palazzo Marcello, in which Frederick Rolfe died in poverty in 1913, not to achieve fame as a writer until many years later. Beyond the Vendramin-Calergi palace can be seen the top of the façade of the church of S. Marcuola and behind it the campanile of S. Geremia.

Visentini's engraving corresponds very closely, but not exactly, with a painting which bears on the back a torn label on which is inscribed, in an eighteenth-century hand, "Painted for Henry Duke of" This is said to have been Henry Grey, twelfth Earl of Kent, who was created Duke of Kent in 1710 and who died in 1740. There are good grounds for thinking that he bought the painting direct from Joseph Smith or, perhaps, commissioned it, using Smith as intermediary, Smith keeping Visentini's drawings which are now in the British Museum and Correr Museum. The painting was sold in London during the Second World War and its whereabouts is unknown.

Original painting: unknown.

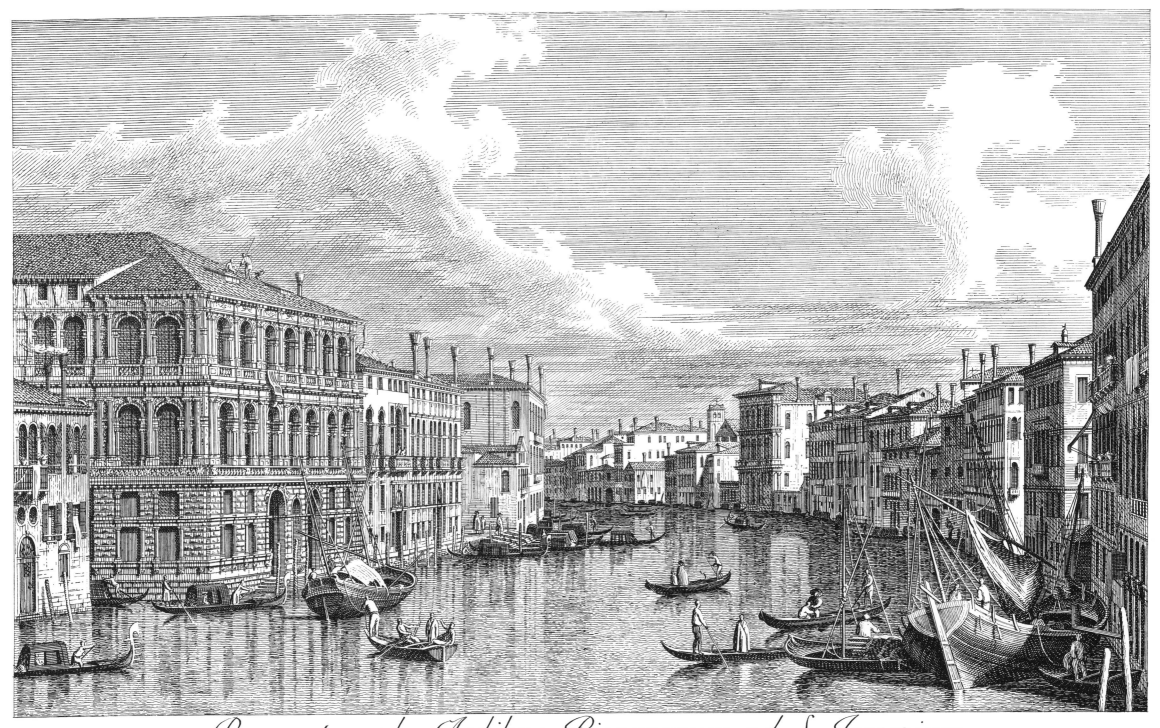

Prospectus ab Aedibus Pisaurorum ad S. Ieremiam.

6.

Grand Canal: looking South-East from the Palazzo Michiel dalle Colonne to the Fondaco dei Tedeschi.

This is the last of the engravings showing the Grand Canal north of the Rialto Bridge. We have turned towards the Bridge again and, dominating the right of the picture, are the Fabbriche Nuove, the New Buildings of the Rialto, the "Substructionibus Rivoalti" of the Latin title, which we saw in the far distance of Part II, No. 5; we also saw them in the opposite direction on the left of Part I, No. VIII. The fruit and vegetable and fish markets have been on these quays for many centuries and present the liveliest scenes in all Venice in the early morning; everything, of course, is delivered and taken away by boats of one kind or another.

It is from a point on the edge of the quay that the palaces of the left bank present themselves at the angle Canaletto painted them; to show the Canal façade of the Fabbriche Nuove he would then have had to leave his first viewpoint and take to the water. The first two palaces on the left, and the small house between them, belonged to the Michiel family whose first Doge, Vitale, was assassinated in 1102 (see Part II, No. 11). The first is known as Michiel dalle Colonne from its colonnade and the second as Michiel del Brusa after a fire which nearly destroyed the Gothic building in 1774. Beside it, on the same side of the rio, is part of the small palace, then the property of the recently ennobled Valmarana family, soon to become Consul Smith's palace and to be modernized by Visentini. In the Fitzwilliam Museum, Cambridge, England, there is a painting by Marieschi showing the palace encased in scaffold-ing (see p. 7), indicating that the work took eight years, since Marieschi died in 1743 and the palace was not seen by the public until 1751.

Beyond the rio (which leads direct to the Arsenal in the east of the city) is an eighteenth-century house followed by the Ca' da Mosto, for at least two centuries Venice's leading hotel, the Leon Bianco. We are then able to see a group of palaces which were invisible in Part I, No. VIII owing to the curve of the Canal. The one with a walled courtyard on the Canal was leased in 1539 to Pietro Aretino, a notorious blackmailer who became known as "the scourge of princes." He wrote to his landlord, Bishop Bolani, that this was "the finest position on the Grand Canal" and that he enjoyed from it "the fairest highway and the most joyous view in the world," from which he could watch "a thousand people in as many gondolas, grapes in the barges below, vegetables laid out on the pavements in the market opposite, a boatload of Germans who had just reeled out of a tavern being capsized, orange trees gilding the Palace of the Camerlenghi and, at night, lamps like stars scattered over the place where all that was necessary for one's feasts and banquets was sold." But he seldom, if ever, paid his rent to the Bishop in the twenty years he inhabited the palace.

Original painting: formerly Sir Robert Grenville Harvey.

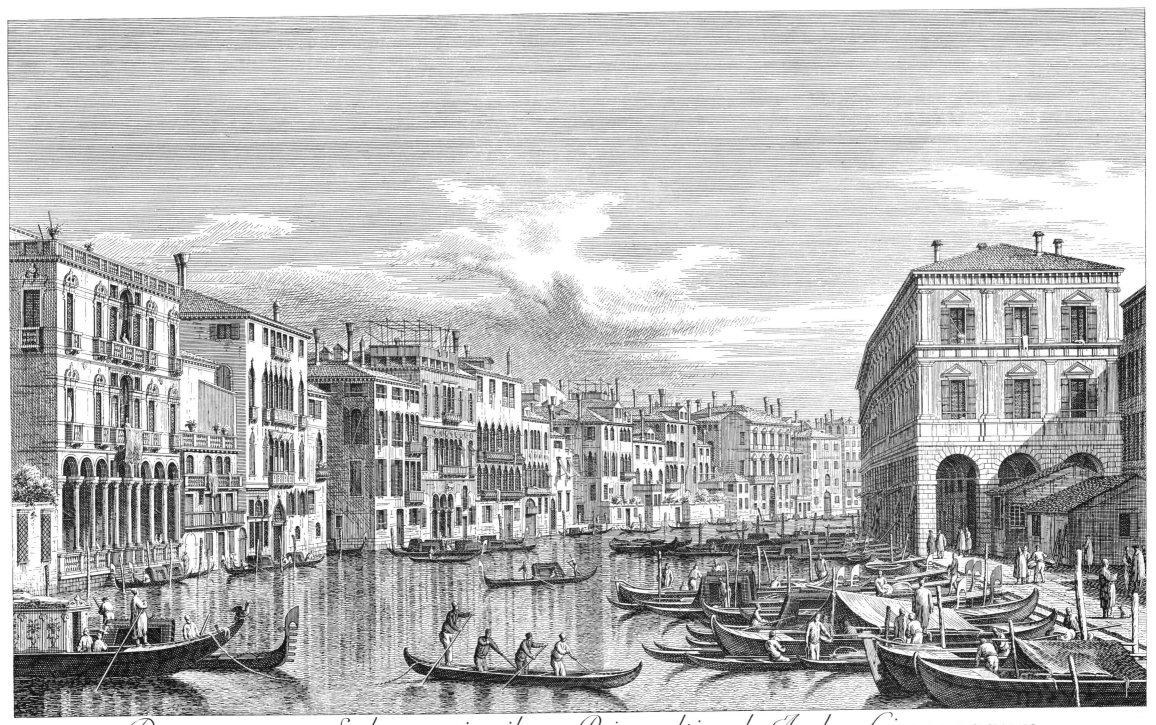

Prospectus a Substructionibus Rivoalti ad Aedes Civranorum. 7.

Grand Canal: the Rialto Bridge from the South.

We are looking in the opposite direction to the scene shown in the first engraving in the book, the intensely busy area just below the Rialto Bridge, with the Riva del Vin on the left and the Riva del Ferro on the right (in this case the Latin description "ad Orientem" is correct whereas in the first picture it was an error). Beyond the Rialto Bridge can be seen the Palazzo dei Camerlenghi on the left and the Fondaco dei Tedeschi on the right (it must have been towards the latter that Aretino saw the Germans approaching when they had reeled out of a tavern: it was their headquarters and the nearby taverns catered mainly for Germans—even the dog welcomed Germans in one of them, according to a writer in 1493, whereas in the presence of Italians, Frenchmen or Greeks "he became so angry you would think he had gone mad"). When, eventually, his landlord managed to get Aretino out of his house for non-payment of rent, the "scourge of princes" moved to one of the houses near the Bridge on the Riva del Ferro, now a café as, indeed, are most of the houses on both sides of the Canal.

On the extreme right is a bridge across the Rio di S. Salvatore, the route by which goods can be taken from the Rialto markets to as near the Piazza S. Marco as a water vessel can attain; it will be seen that it has only one parapet; this was a common feature of old Venetian bridges, many of which had none at all. The bridge leads to the Palazzo Dolfin-Manin, now the Bank of Italy, built by Sansovino in the middle of the sixteenth century for the Dolfin family. In the 1790's it belonged to Lodovico Manin, who had become Doge in 1797. Rather surprisingly he had ambitious plans for enlarging the palace, many of which were carried into effect. Perhaps he had a premonition that he would not die in the Doge's Palace but would return to his home as a private citizen. On the seventeenth of May, 1797 the Great Council of the *Serenissima* voted to accede to Napoleon's demand for capitulation. Manin handed his *corno*, the Doge's bonnet, to his servant with the words, "Take it, I shall not need it again," and the last Doge abdicated exactly 1100 years after the first one had been elected. Manin first took refuge with his family at the Ca' Pesaro and then in 1801 returned to his palace on the Grand Canal just as he may have foreseen.

Canaletto painted many pictures from or near this viewpoint, few of them of high quality. The version in Paris, which corresponds in detail with Visentini's engraving, was for many years not regarded as by Canaletto at all; it is now accepted in spite of its mechanical quality. Note the *burchiello* on the left. We saw this barge on the way to and from Padua in the first two engravings of Part II. Here it is probably at its terminus.

Original painting: Musée Jacquemart-André, Paris.

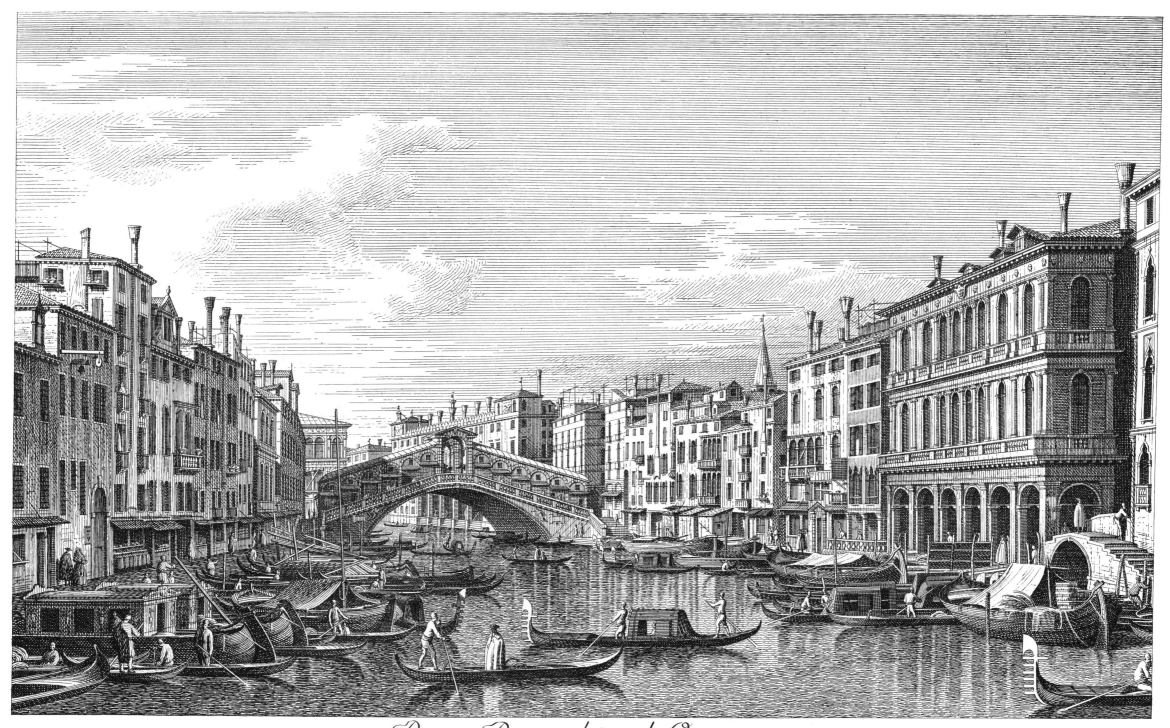

Pons Rivoalti ad Orientem.

8

Grand Canal: looking South-West from the Palazzo Grimani to the Palazzo Foscari.

This is little more than an enlargement of the background of our first engraving. The Palazzo Grimani, then in the middle distance, now dominates the left of the picture. Even John Ruskin, who wrote *The Stones of Venice* in order to strike "effectual blows at this pestilent art of the Renaissance," admired the noble proportions of this masterpiece by Sanmichele, built in the second half of the sixteenth century. Almost opposite (the palace with the obelisks on the right-hand side) is the Palazzo Coccina-Tiepolo ("Theupolorum" of the Latin title), built for the very wealthy, but not patrician, family of Coccina. Soon after the palace was finished, it is said, a Grimani was suitor for the hand of a Coccina and it was pointed out by the girl's father that, in spite of their illustrious lineage, there was no great Grimani palace on the Grand Canal. From this taunt grew the present Grimani palace, according to the story, enabling the young Grimani to boast that any one of its principal windows was bigger than his father-in-law's main portal.

The first palace on the right is called Businello, formerly one of the many Giustinian palaces. It has the remains of its Byzantine origins in its structure, as have four other palaces in this area. Five hundred years before the Grimani and Coccina families tried to surpass one another in their magnificence, the Grand Canal was already a street of private houses. It must be remembered, though, that the Venetian nobility were merchants rather than landed proprietors and their houses were used also for the storage of their goods and conduct of their affairs.

The painting from which Visentini made his engraving has disappeared but there is a painting from a lower viewpoint, slightly to the right, in the collection of the Earl of Normanton of Hampshire, England. For this picture Canaletto filled six pages of his sketchbook, now in the Venice Academy of Fine Arts, with meticulous drawings of the palaces, noting the colours of the various stones used for them as well as their architectural details. The far distance of the sketches, though, showing the Palazzo Foscari looking up this long straight stretch of the Canal, corresponds with neither the Normanton painting nor Visentini's engraving; Canaletto may well have painted another picture of the scene which has disappeared.

Original painting: unknown.

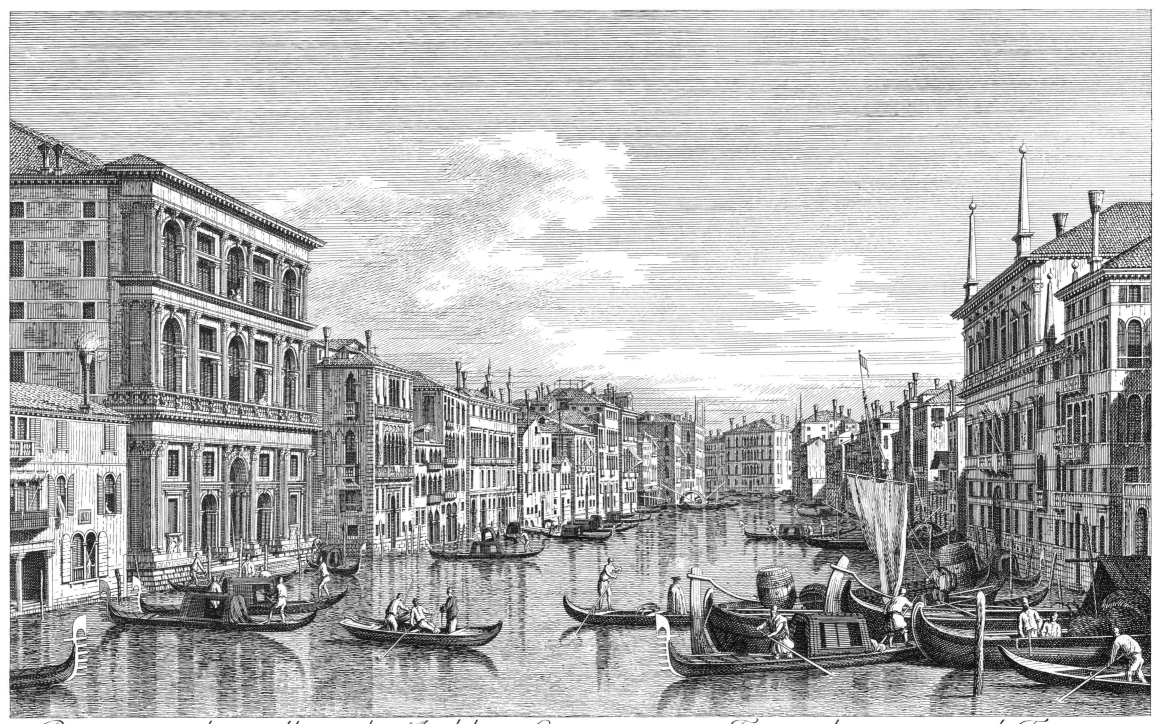

Prospectus hinc illinc ab Aedibus Grimanorum Theupolorumque ad Foscaros. 9.

Grand Canal: looking North-West from the Palazzo Corner to the Palazzo Contarini dagli Scrigni.

In Part I, No. VI, the first picture for which he turned and looked up the Grand Canal, Canaletto ended the palaces on the right with the Palazzo Corner. Here it is the first and the view is unimpeded until the Canal turns to the right at the point where the Accademia Bridge now crosses it. The Palazzo Corner della Ca' Grande is another of the Renaissance palaces such as the Grimani, Coccina-Tiepolo and Pesaro, built, it sometimes seems, to vie with each other: this, in Ruskin's opinion, was "one of the worst and coldest." It is now the Prefecture. Beyond it can be seen the top of the huge Palazzo Pisani, in the Campo S. Stefano, now the Conservatory of Music. Canaletto's sketch-book, already referred to, contains detailed drawings for this painting but they start with the far end of the Palazzo Corner and the complete façade of the palace appears in the finished picture at a quite different angle from that at which a spectator at this point would see it. On the left of the Palazzo Pisani is the south side of the garret of the Palazzo Barbaro; Ruskin's comment on its occupation by the last of the family is quoted under Part I, No. III.

The palaces on the extreme left no longer exist. They were demolished to make way for the Palazzo Venier dei Leoni; only one storey of the palace was completed and this is now occupied by Mrs Peggy Guggenheim and her art gallery. Two tall palaces, which are still standing, follow. The first is the Gothic Palazzo da Mula and the second the Palazzo Barbarigo, the side façade of which looks on to the Campo S. Vio; we saw it in full sunshine in Part I, No. IV but now the sun is shining on the Palazzo Loredan on the other side of the campo. A little farther on we come to the buildings of the Carità with its campanile, which was to collapse within a few years of Canaletto's picture being painted; the pinnacles of the church of the Carità (now the Academy of Fine Arts) are visible beside the campanile. In the distance is the tower of the Palazzo Contarini dagli Scrigni. Branches of the Contarini family took various names to distinguish one from another and in this case the family were called after the chests (scrigni) which were let into the walls of their huge villa on the mainland.

We have come to the end of Canaletto's tour of the Grand Canal. In his twenty-three pictures he has shown almost every palace—over a hundred of them separately identifiable and most of them still standing. Visentini's engravings have enabled us to study the paintings in black and white through the eyes of a fellow artist. In this particular case we are also fortunate in being able to compare a drawing by Canaletto himself of the scene (Fig. 2, p. 5) and to appreciate his mastery of the pen as well as of the brush.

Original painting: perhaps the Duke of Bedford, Woburn Abbey; there are, however, many differences both in the shipping and the proportions of the buildings.

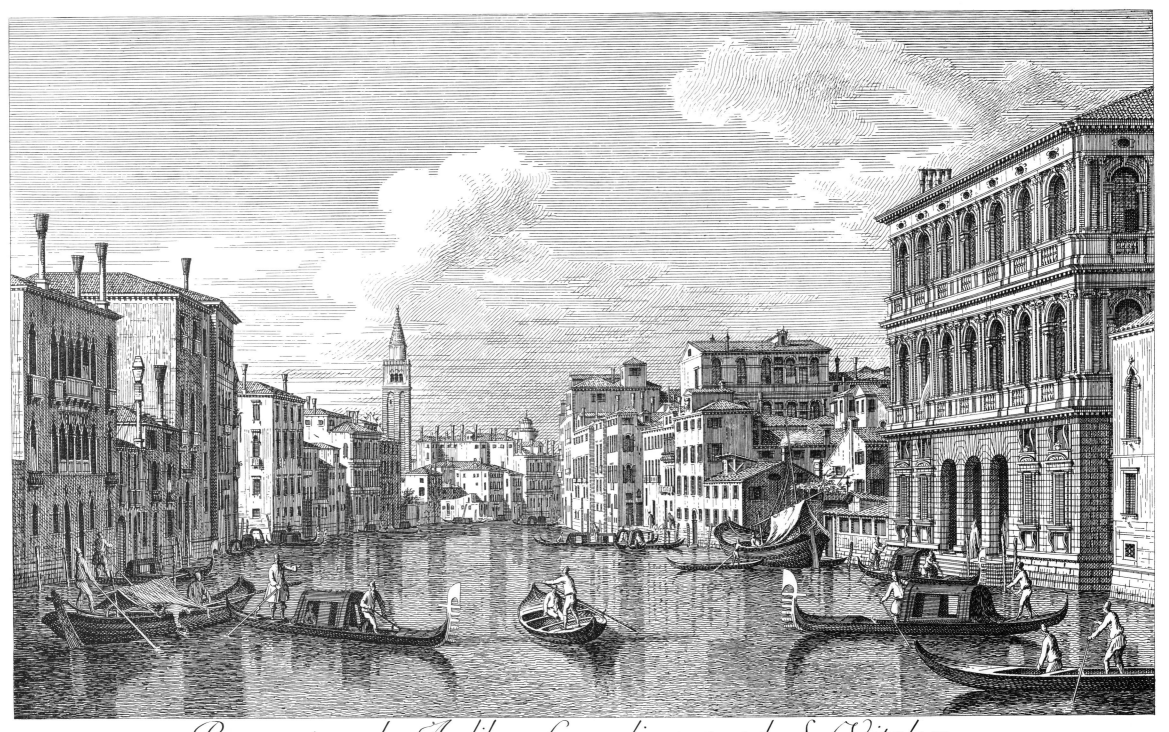

Prospectus ab Aedibus Corneliorum ad S. Vitalem.

JO.

Riva degli Schiavoni: looking East.

Part II ends, as did Part I, with engravings of two much larger paintings than any of the Grand Canal scenes, in this case looking in opposite directions from approximately the same viewpoint. Here we have, in effect, an enlargement of part of the scene shown on the left of Part I, No. v and described under that engraving. In the foreground is the Molo, or quay, on which stands the Doge's Palace, then the Ponte della Paglia leading to the Prison. The Riva degli Schiavoni begins at this bridge and extends into the far distance, with an occasional change of name. The Schiavoni were the Slavs, or Dalmatians (hence the Latin title), who traded with Venice, parts of their country being under Venetian domination for long periods. The column of St Mark, surmounted by the Lion of St Mark, appears to be in front of the Doge's Palace: its true position on the Piazzetta can be seen by comparison with Part I, No. xiv.

Beyond the Prison are some mean buildings and then the Palazzo Dandolo, built in the fifteenth century, often used for the accommodation of distinguished visitors, and, since 1822, the Hotel Danieli. Near here, in 1102, Doge Vitale Michiel I was murdered, and his assassin took refuge in one of the houses between the Prison and the Palazzo Dandolo. After his execution it was decreed that the houses be demolished and never again rebuilt in stone. For eight hundred years one of the most important sites in Venice was therefore without any building of consequence and it was not until 1945 that the Hotel Danieli was permitted to build a modern extension on it. There has been a paved embankment here for at least six hundred years but in Canaletto's time it was, as can be seen, no wider than the old Ponte della Paglia; it was extended to the same width as the Molo in 1782.

Unless Canaletto was able to make his sketches for the painting from high in the rigging of a ship moored on the Molo, he must have worked out mathematically the perspective of his scene, for there is no building from which it could have been drawn. This, no doubt, was well within his powers and he painted a series of pictures from various purported viewpoints high above the waters of the lagoon in this area. The one from which Visentini's engraving was made was one of a group of four paintings said to have been bought from Joseph Smith by a Duke of Leeds; probably the fourth as the second and third Dukes died in 1729 and 1731 respectively. It was sold by the tenth Duke in 1920 and is now in Rome.

Only four of Canaletto's superb etchings, published about 1745, are of Venice itself. One of them (Fig. 5, p. 6) is from a point on the Molo in the near distance of the present picture. Visentini's outline drawing, now in the Corror Museum, Venice, doubtless used in connection with his engraving, is also reproduced (Fig. 6, p. 7); all the Corror Museum drawings are similar in technique to this one.

Original painting: Albertini Collection, Rome; there are slight variations; $43\frac{1}{2} \times 73$ inches.

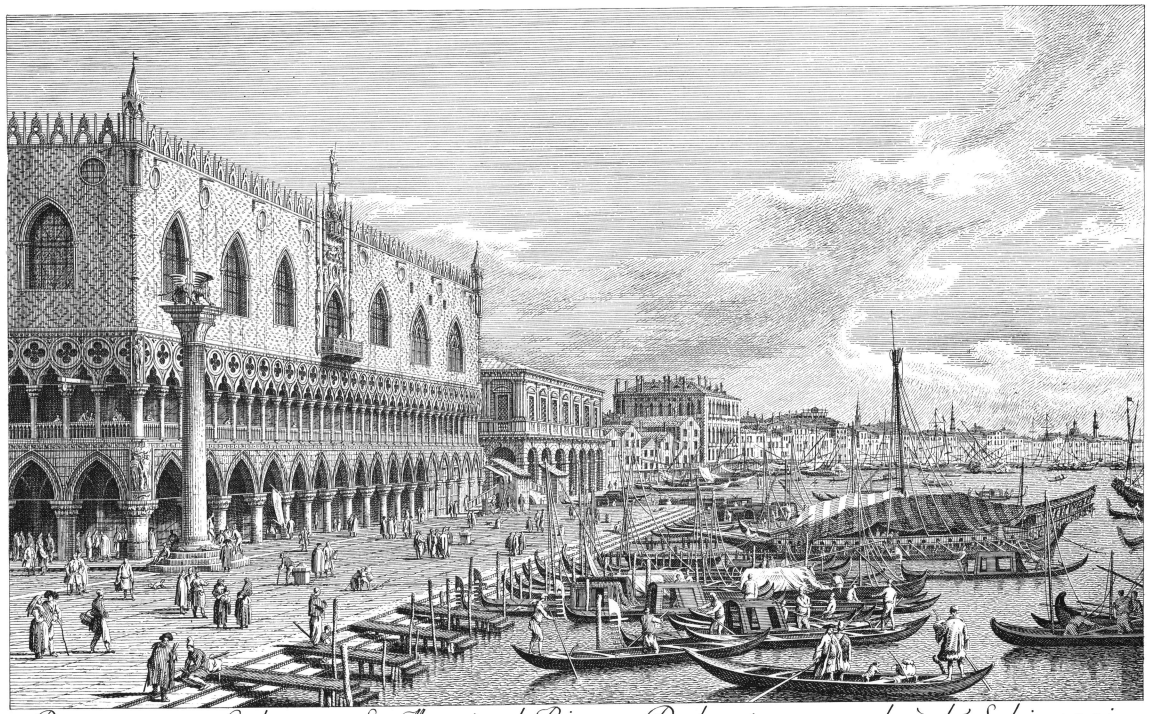

Prospectus a Columna S. Marci ad Ripam Dalmatarum vulgò de' Schiavoni. JJ.

The Molo: looking West, Column of St Theodore Right.

Canaletto has turned in the opposite direction from his last picture. His purported viewpoint is still far above a man's height but now he has moved in from the water and is above the Molo itself. No ship could have provided a vantage point and there is no building: only calculation in the studio could have enabled Canaletto to give conviction to his painting.

On the right is the granite Column of St Theodore, Venice's patron saint until his displacement in 829 by St Mark. This and the neighbouring Column of St Mark were brought from the East some nine hundred years ago and there is said to have been a third column which was lost when they were being unloaded. The engineer who succeeded in erecting the remaining two was given the gambling monopoly of the city as a reward—but the sessions had to be held between the columns where the scaffold for executions also stood. Behind the Column is the corner of the Library of St Mark begun by Sansovino in 1536; after ten years' work part of it collapsed and Sansovino was imprisoned for negligence. The Library was still unfinished when Sansovino died in 1570 and Scamozzi completed it in 1582.

Beyond the Library are the Zecca (mint, where the gold ducats, or *zecchini*, were minted up to 1870), now part of the Library, and then the Public Granaries, which were demolished by Napoleon to make a garden for his Royal Palace; the palace itself was in the Procuratie Nuove which form the south side of the Piazza S. Marco. The little building at the end of the Molo was called the Fondeghetto della Farina (wheat warehouse) and was later the first home of the Academy of Fine Arts. In the nineteenth century Napoleon replaced it by the pavilion, later to become the Bucintoro Rowing Club and now the air terminal. The Molo itself is crowded with temporary canvas booths and at the foot of the Column are men with bird-cages and coops.

In the centre is the entrance to the Grand Canal, with the tower of the Palazzo Venier dalla Torresella visible in the distance, and the Dogana and Church of the Salute on the left. To the left of the Dogana, behind the sailing vessel, we see the Giudecca Canal along which the greatest ships can make their way to the docks of the Port of Venice or farther on to the oil refineries at Mestre on the mainland. On the extreme left we can see Palladio's Church of the Redentore (Redeemer) on the Island of Giudecca; a bridge of boats is built across the Giudecca Canal to it every July, originally to enable the Doge to cross and give thanks for delivery from a plague.

The original painting is one of four, formerly belonging to the Duke of Leeds, said to have been bought direct from Joseph Smith. There are several different versions from varying viewpoints, none of which could have been attained in practice by the artist.

Original painting: Albertini Collection, Rome; there are slight variations; $43\frac{1}{2} \times 73$ inches.

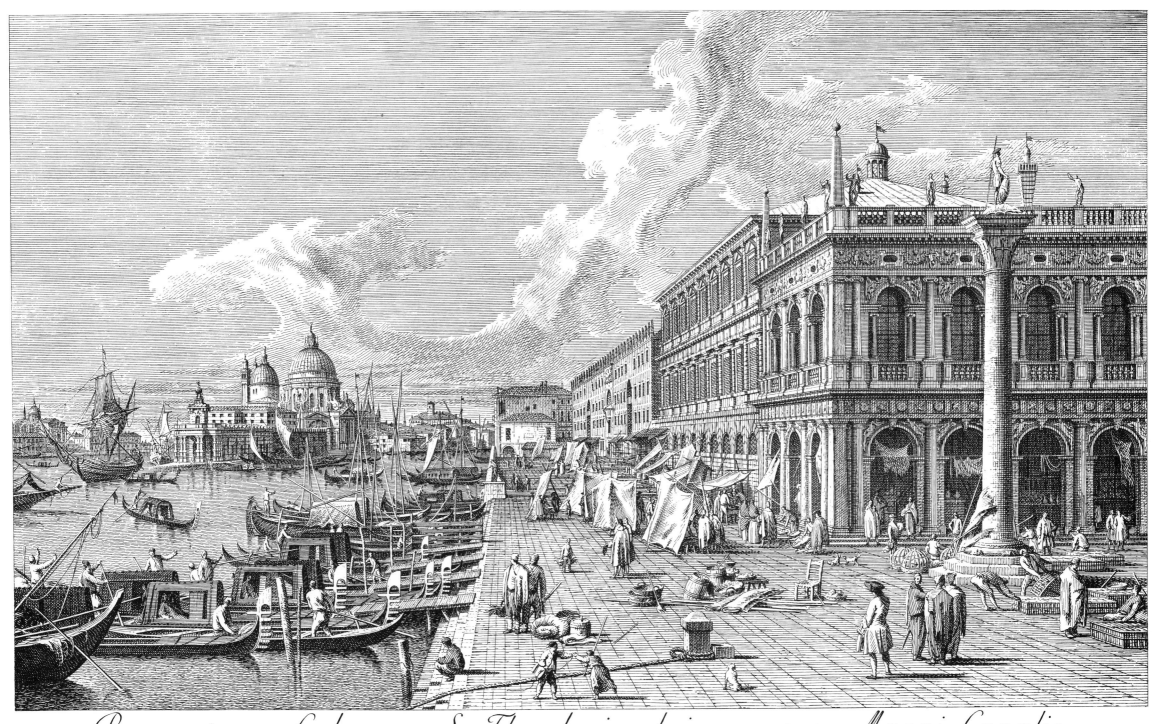

Prospectus a Columna S. Theodori ad ingressum Magni Canalis. 12.

PART THREE / NO. I
SS. Giovanni e Paolo and the Monument to Bartolommeo Colleoni.

Canaletto has now left the Grand Canal and the lagoon and for the remaining twelve pictures devotes himself to the enclosed *campi* of Venice. A *campo* is a field and the churches of the city were originally surrounded by grass grown for pasturage, watered from the well which can still almost invariably be noted from a decorated well-head in the *campo*. Of all the Venetian *campi*, that of SS. Giovanni e Paolo is perhaps the best known and most visited, and it must have seen greater funeral spectacles than any other: twenty-five Doges were buried in its church between 1249 and 1778. It is one of the two great Gothic churches of Venice, the other being that of the Frari (which Canaletto never used as the subject of a painting or drawing).

The canal in the foreground is the Rio dei Mendicanti (beggars) which leads, through the Ponte del Cavallo (horse) on the extreme left, to the Fondamente Nuove and the northern part of the lagoon. Before the Fondamente Nuove (new embankments) were built at the end of the sixteenth century the church (which Venetians call S. Zanipolo) was on the edge of the lagoon itself. To the left of the church is the façade of the Scuola di S. Marco, formerly also on the lagoon, built by the Lombardo brothers and finished by Mauro Coducci in 1495 for the brothers of the Guild of St Mark, whose earlier *scuola* had been burnt down. It is now the principal hospital of the city.

The name of the *scuola* led the Venetians out of an embarrassing situation when Bartolommeo Colleoni, a successful mercenary general, left them his fortune, which they badly needed at the time, on condition they built an equestrian monument to his memory in the Piazza S. Marco. Such a thing was illegal and out of the question but it was considered that a statue outside the Scuola S. Marco would be almost equivalent. Andrea Verrocchio was accordingly commissioned to design the statue, which was cast, after Verrocchio's death, by Alessandro Leopardi and is considered perhaps the greatest equestrian monument in the world. The statue is seen in the *campo* with the well-head beside it and the transept and dome of the church behind. Hardly anything has changed today, not even the buildings on the right of the picture.

Apart from the fourteen of Part I, this was the only painting of the series in Joseph Smith's collection at the time he sold it to George III. By that time most of the others seem to have been in England. It appears likely that, twenty years earlier, when the engravings for this book were being prepared, all the paintings were in Smith's possession.

Original painting: H. M. The Queen, Windsor Castle.

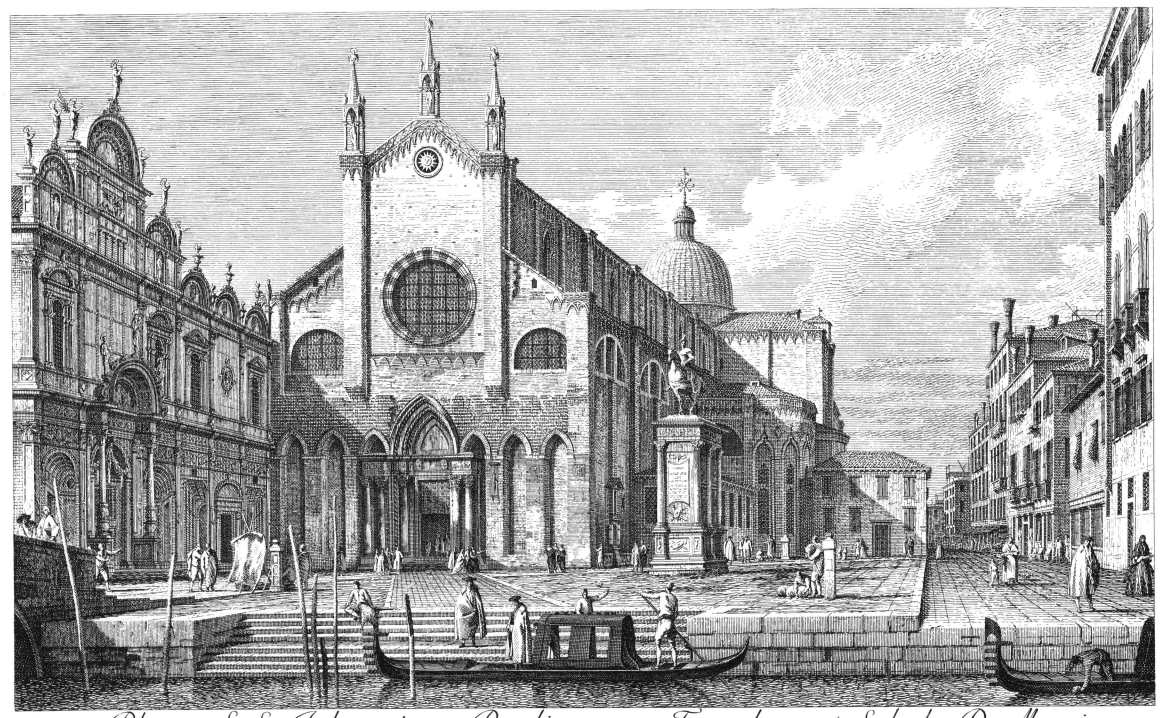

Platea S. S. Iohannis et Pauli, eorum Templum et Schola D. Marci. I.

PART THREE / NO. II
S. Nicolò di Castello.

In contrast to so many of the subjects of this book, the scene shown in this engraving is seldom visited by today's visitor to Venice and has changed almost beyond recognition. The church of S. Nicolò di Castello, which is seen on the right, was demolished in the time of Napoleon when the Public Gardens were built. It seems to have fallen into disuse as a church, however, long before that, since the building is shown as the "Seminario Ducale" in a map of 1729. The church in the centre, S. Giuseppe di Castello, was already used as a convent in Canaletto's time and is now a naval institute. The canal on the left is the Rio di S. Giuseppe and many of the houses along the canal are still in existence. Note that the bridge across the *rio*, like so many Venetian bridges of the period, has no parapets.

This is the Castello district of Venice, Castello being one of the six *sestieri* into which the hundred islands which comprise the city are divided. Castello, so called after a castle which once stood at its most easterly point, is the largest and most crowded *sestiere*; the whole of the city east of the Doge's Palace and of SS. Giovanni e Paolo (subject of the last engraving) is included in it. For many centuries the area has been periodically increased by land reclamation and Canaletto's picture provides a characteristic example. All the land in the foreground has been extended by some hundred and fifty metres and on this has been built the Public Gardens; each alternate year since 1895 the Biennale exhibition of modern art has been held in these gardens. It would almost seem that preparation for this work is in evidence in the picture and that Canaletto might have chosen this rather dull subject in order to record a district about to be changed: so far as is known, though, the reclamation was not begun until many years later.

The original painting from which Visentini's engraving was made was one of the Harvey group (see Part II, No. 2). It was sold when the group was dispersed in 1957 and was exhibited in the Exhibition of Venetian View Painters in Venice in 1967, when many of Canaletto's paintings returned to his native city for the first time in more than two hundred years.

Original painting: Alemagna Collection, Milan; formerly Sir Robert Grenville Harvey.

Area S. Iosephi, cum Templo S. Nicolai ad Castrum.

II.

Campo S. Salvatore.

The church of S. Salvatore is on the left; the building facing us in the centre is the Scuola di S. Teodoro. Every visitor to Venice knows this little *campo*, as it is on the *mercerie*, the busiest shopping street in the city, which also provides the shortest route from the Piazza S. Marco to the Rialto Bridge. A *merceria* is a street lined with shops (originally mercers' or drapers' shops) and this street is divided into four parts, the one emerging from the extreme left being the Merceria S. Salvador (or Salvatore); on reaching the *campo* the pedestrian turns right and proceeds towards the viewpoint Canaletto chose for his painting, which is in the Merceria 2 Aprile (named after the day in 1849 when the Venetians decided to resist the Austrians "at any cost"); a little farther on he would come to the Rialto Bridge.

A column now stands in the centre of the *campo* in remembrance of March 22, 1848, the day on which the Venetians, defying the Austrians, proclaimed a provisional government and so began the seventeen months of heroism and disaster which ended in the return of the Austrians in August 1849. Where this column stands there was once a fig-tree to which riders had to tether their horses before proceeding on foot to the Piazza. This order was issued in 1291, when the use of horses in Venice was general, the streets being unpaved and the bridges flat. When the bridges came to be built of stone, and arched so that gondolas could pass under them, the use of horses declined and died out altogether by the middle of the sixteenth century. However, in 1292 it was necessary to decree that anyone who proceeded farther than the fig-tree in the Campo S. Salvatore on horseback became liable to twenty-five lashes.

The church of S. Salvatore is said to have been founded in the seventh century and to have had originally a floor of iron grating, with running water underneath, like the Holy Sepulchre at Jerusalem. The present building was designed by Giorgio Spavento but it was built under the supervision of the Republic's most distinguished architects, the Lombardo brothers and Sansovino. In 1660 the body of Caterina Cornaro, Queen of Cyprus (see II, 5), was brought here in state after lying for a hundred and fifty years in the church of SS. Apostoli nearby. Three years later, in 1663, the present façade was added to the church.

The Scuola di S. Teodoro was built about 1530 for the last of the six great Guilds or confraternities, then just founded. The façade was added about the same time as that of S. Salvatore. Until recently used as a cinema, the building now houses frequent art exhibitions.

Original painting: private collection, London; formerly Sir Robert Grenville Harvey.

Platea S. Servatoris, ejus Templum et Schola S. Theodori.

III.

PART THREE / NO. IV
Campo S. Polo.

The largest *campo* in Venice, this is one of the least known to visitors. It is on the "far" side of the Grand Canal in respect to the Piazza S. Marco, *de ultra* as opposed to *de citra*; one passes through it on the way from the Rialto Bridge to the church of the Frari but apart from this it is not on a main route and its church (behind the spectator on the left in the picture and therefore not visible) has relatively little to offer the tourist. The picture, as the Latin title indicates, is one of private houses, the largest of which is the Palazzo Corner Mocenigo in the left background; this was built in 1509 and occupies the site of a palace formerly given to foreign friends of the Republic (and confiscated when they fell out of favour).

Canaletto chose a quiet day for his painting but the *campo* was for many centuries the scene of fêtes, tournaments and bull-fights. Military reviews were held here, and there was generally a market. In 1809 the weekly market formerly held in the Piazza S. Marco (the "Nundinae Venetae" of Part I, No. XIV) was transferred to the Campo S. Polo.

The farthermost house of the row on the right still bears a thirteenth-century doorway. It was marked by the Republic with the lion of St Mark after Bajamonte Tiepolo had organized an abortive conspiracy against the Doge in 1310: this showed that the house had belonged to one of the conspirators and had been confiscated.

In the right foreground is one of several palaces belonging to, and named after, the Tiepolo family and beyond it is a pair of Gothic palaces which belonged in Canaletto's time to the Soranzo family. In 1746, some ten to fifteen years after the picture was painted, the celebrated libertine Giacomo Casanova, then twenty-one, was, in his own words, "one of the fiddlers making up one of the several orchestras for the balls which were given for three days in the Palazzo Soranzo" on the occasion of a family marriage. As he left on the third day, an hour before dawn, he was befriended by a man who was seized by a stroke within a few minutes. Casanova saved the life of this man, who proved to be the highly influential Senator Bragadin and who adopted Casanova as a son—"which raised me at one bound from the base role of a fiddler to that of a nobleman," he wrote later.

A *rio* ran in front of the palaces on the right, ending just before the Palazzo Tiepolo; signs of it can still be seen in the paving. Parapets have been built around it for the protection of passers-by and the bridges leading over it to the doors of the houses are flat.

Original painting: formerly Sir Robert Grenville Harvey.

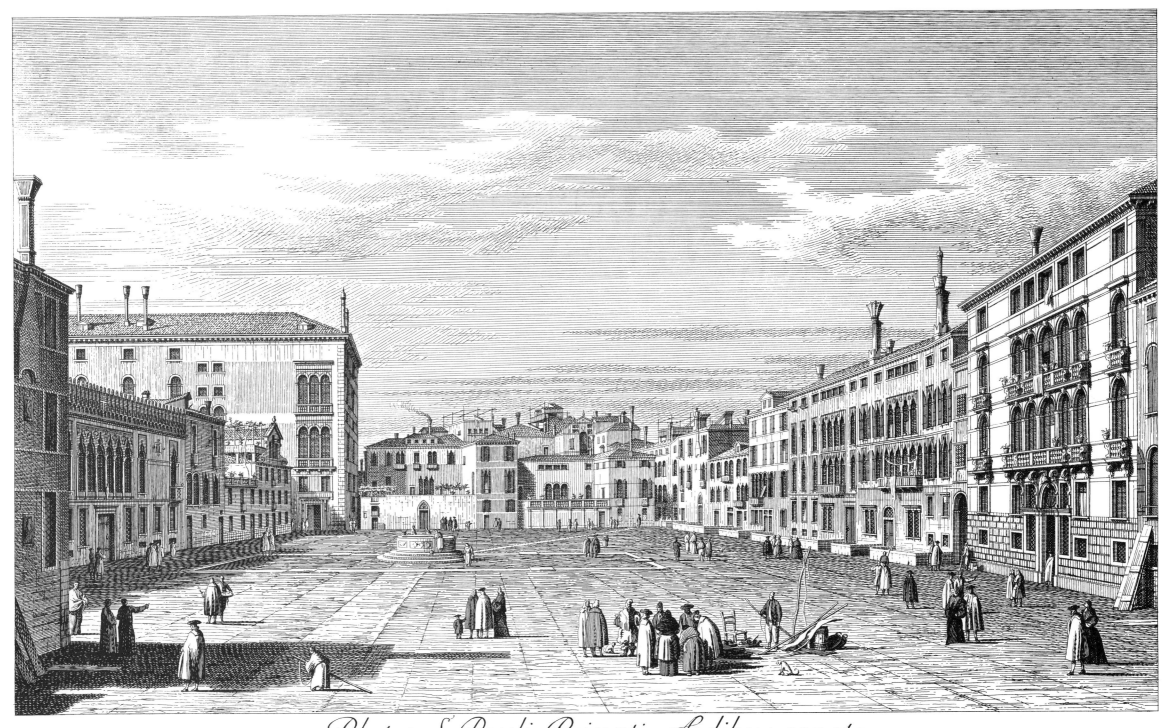

Platea S. Pauli Privatis Aedibus ornata.

IV.

PART THREE / NO. V

Scuola di S. Rocco.

We are still *de ultra*, on the far side of the Grand Canal; only this and the previous picture in the series take us to this part of Venice. The church of S. Rocco, seen on the right, and its neighbouring *scuola*, facing us, are behind the church of the Frari: the shadow of its apse can be seen in the left foreground.

The Scuola di S. Rocco was one of the six great Guilds of Venice, and their building, begun in 1515, took fifty years to complete. John Ruskin considered it one of the three most precious buildings in the world (with the Sistine Chapel and Campo Santo of Pisa) by reason of its housing the matchless series of thirty paintings by Jacopo Tintoretto to which he devoted twenty-two years from 1564 onwards.

It is a quiet day, as in the case of the last picture, of the Campo S. Polo, but Canaletto had previously painted from the same viewpoint on the great occasion of the annual visit of the Doge on the sixteenth of August. This was to mark the intercession of St Roch (whose body had been brought to Venice in 1485) which saved the city from the plague of 1576. Canaletto's painting of this event, in the National Gallery, London, has become one of his most celebrated masterpieces.

In the National Gallery painting, the façade of the church of S. Rocco on the right is of brick and unfinished. In the late 1720's the old façade, known from an engraving of 1703 by Luca Carlevaris, was removed and only the brick underwork remained until 1771, when the present façade was completed. Meanwhile artists seem to have felt free to show the church with a façade of their own invention. For his painting from which the present engraving is taken Canaletto designed a simple pedimented façade with four double pilasters and a door of normal proportions. Visentini followed the painting meticulously until he came to the façade of the church. This he evidently regarded as the cadenza of a concerto, giving him the right to make his own improvisations rather than follow Canaletto's. Moreover, as an architect, he seems to have felt constrained to produce something far more elaborate than Canaletto; his façade is also more convincing than those invented by other artists such as Francesco Zucchi in 1740 or Michele Marieschi in 1741, both of whom put fantastic caprices in place of the dull brickwork faithfully portrayed by Canaletto in his National Gallery painting.

The campanile in the left-of-centre background is that of the church of S. Pantaleone.

Original painting: private collection, Italy; the church façade, on the right, differs in the engraving from the painting.

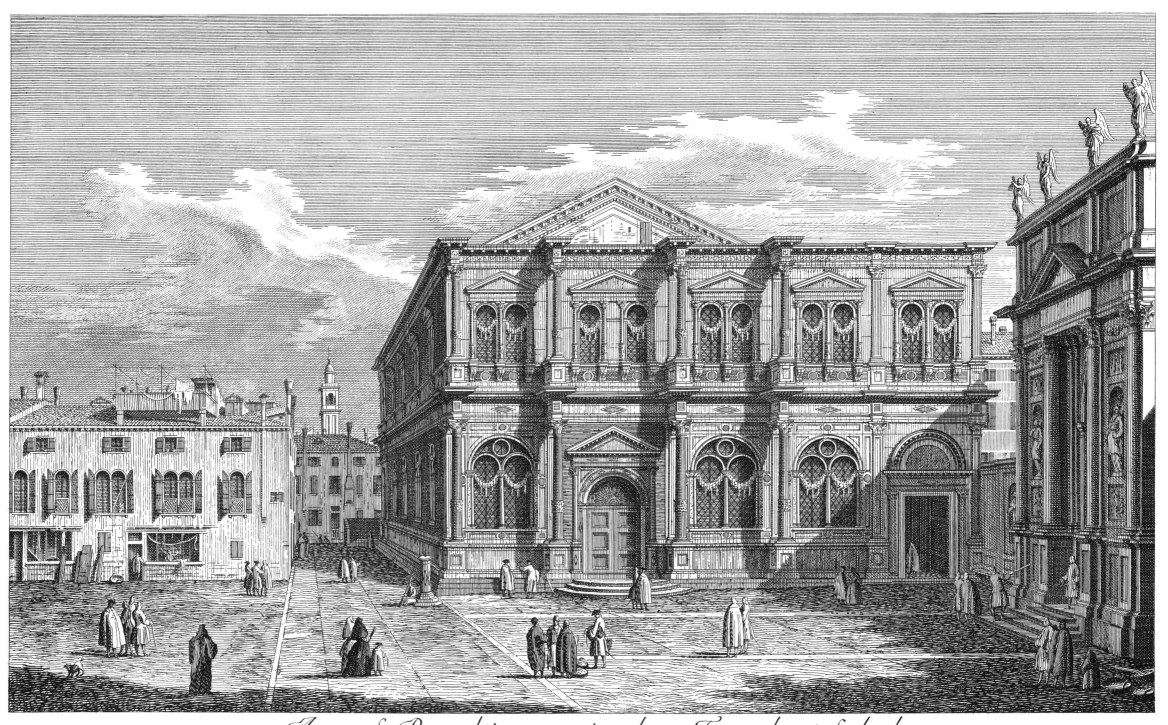

Area S. Rocchi cum ejusdem Templo et Schola.

V.

Sta. Maria Zobenigo.

We return to the beaten track, for most visitors to Venice pass this *campo* frequently on their way from the Piazza S. Marco, or their hotels on the Grand Canal, to the Accademia Bridge. The Grand Canal and houses on the far side of it can be seen on the extreme left. For centuries there was a *traghetto*, or ferry, here but it was recently discontinued; the gondoliers' shelter remains. All the houses shown between the church and the Grand Canal remain today.

John Ruskin lived on this *campo* in 1851, when he was working on *The Stones of Venice*, in what was then the Casa Wetzlar and is now the Gritti Palace Hotel; it is on the Grand Canal, just out of sight of the picture. He therefore had to pass the church of Sta. Maria Zobenigo frequently and he was affronted by its façade. "Instead of saints," he wrote to his father, "there are . . . four statues of the Barbaros": it was a "manifestation of insolent atheism." When he found the last of the Barbaro family reduced to poverty he made the comment quoted under Part I, No. III.

The façade of the church, which is also known as Sta. Maria del Giglio (of the lily), was built, at the expense of the Barbaro family, between 1678 and 1683. Below the coupled columns which frame the four statues are five relief plans of cities or fortresses of the Venetian Empire and one of Rome. The level of the *campo* has been raised (as has often occurred throughout Venice), resulting in the lower plinth of the church now being covered and the four outside steps being replaced by inside ones. Otherwise little has changed. The campanile collapsed in 1774 and its stump now serves as a small picture gallery; its predecessor must also have fallen, as a famous woodcut of 1500 shows a stump in its place. The Jubenigo family who built the original church about 900 became extinct as long ago as 1124; their name has thus been perpetuated for over 800 years.

Canaletto is frequently said to have used an optical instrument such as a camera obscura for his work and may have done so for his preliminary sketches, although most improbably for anything more finished. In the present case no such instrument would have served him, as the *calle* in which the church stands is (and was in Canaletto's time) but ten yards wide. In order to produce a picture which appears to be from a far more distant viewpoint than was possible, he must have made a number of sketches and then made theoretical calculations in his studio to produce a convincing perspective.

The bridge of boats which is built twice a year across to the Salute starts from this *campo*.

Original painting: Mrs Charles Wrightsman; formerly Sir Robert Grenville Harvey.

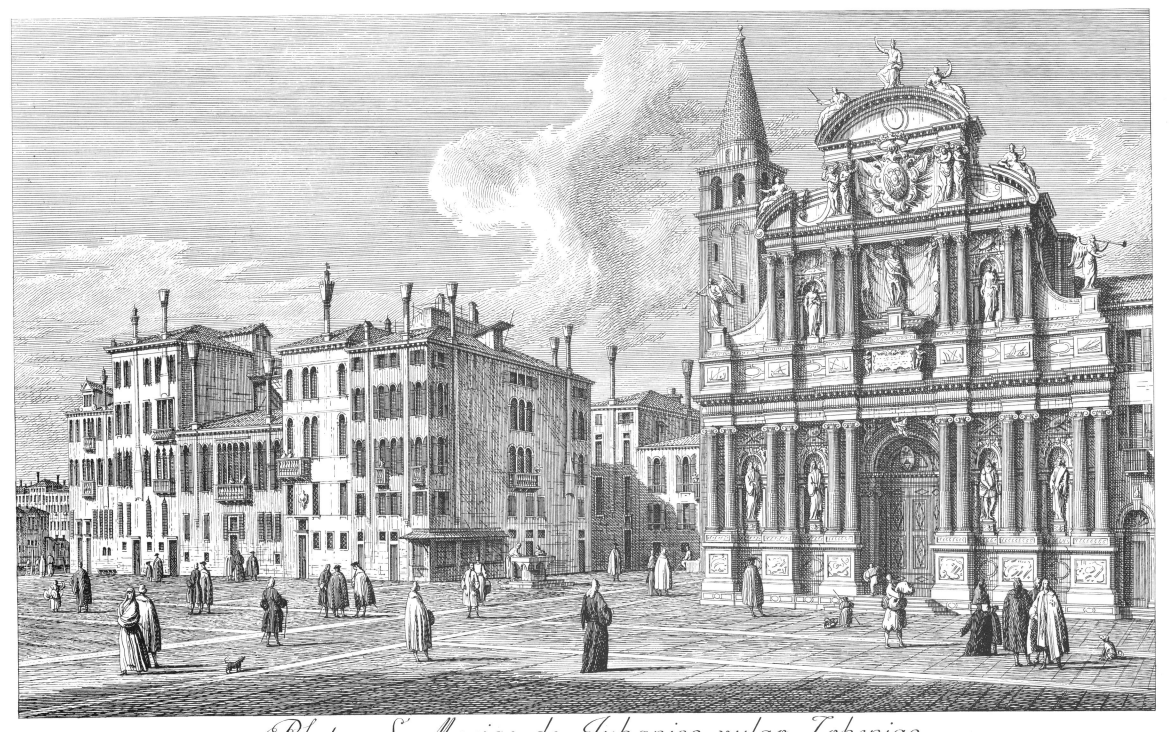

Platea S.ᵗ Mariae de Iubanico vulgo Zobenigo.

VI.

Campo S. Stefano.

The Campo S. Stefano is one of the largest and busiest *campi* in Venice. It is on the route from the Piazza S. Marco, to which the *calle* on the left between the two groups of shops leads, and the Accademia Bridge. A glimpse of the Grand Canal can be seen in the background and it is about here that the bridge now joins the *campo*. The same point can be seen from the Grand Canal side on the extreme left of Part I, No. III where the two gondolas are beached. For many years the *campo* was officially named after Francesco Morosini, whose palace is reached through the monumental entrance seen left of centre. He was the last successful Commander to serve the Republic and was responsible for the death or capture of 200,000 of its enemies, it was said; it was his bombardment of Athens against the Turks in 1688 which destroyed the Parthenon, then used as a powder magazine. Venetians have generally preferred the name of S. Stefano to that of Morosini and it has now been officially restored.

The prominent palace on the right is the Palazzo Loredan, rebuilt soon after 1536 by the Loredan family, who had bought the site with a Gothic palace from the Mocenigo family; between them these two families provided ten of the Republic's hundred and twenty Doges. Behind the palace can be seen the top of the campanile of S. Vitale, now used as a picture gallery. (S. Vitale is not to be confused with S. Vito or Vio on the opposite side of the Grand Canal, which appears as "S. Viti" in the Latin title of Part I, No. IV.)

Above the stone entrance to the Palazzo Morosini can be seen the top of the Palazzo Pisani, which was very prominent in the background of another painting of the Bedford series reproduced in Part II, No. 10. The courtyards of the palace, with their columns of Istrian marble, are almost all that is left of the building on which the Pisani family lavished enormous sums of money; it is now the Conservatory of Music.

The church of S. Stefano does not appear in the picture, being behind the spectator. The *campo* was used for bull-fights as late as 1802, when the last bull-fight held in Venice took place here. Five years later the weekly market was transferred here from the Piazza S. Marco but after two years it was again moved, this time to the Campo S. Polo.

Nothing is known of the origin of the twenty-four paintings by Canaletto at Woburn Abbey although they were almost certainly bought by the fourth Duke of Bedford in 1731–2. They were certainly not painted for the room in which they now hang, as is often said; up to 1800 they were at Bedford House, Bloomsbury, London. Of the three engraved by Visentini, only one (Part II, No. 4) follows the painting exactly.

Original painting: the Duke of Bedford, Woburn Abbey, England; there are slight differences, especially in the clouds.

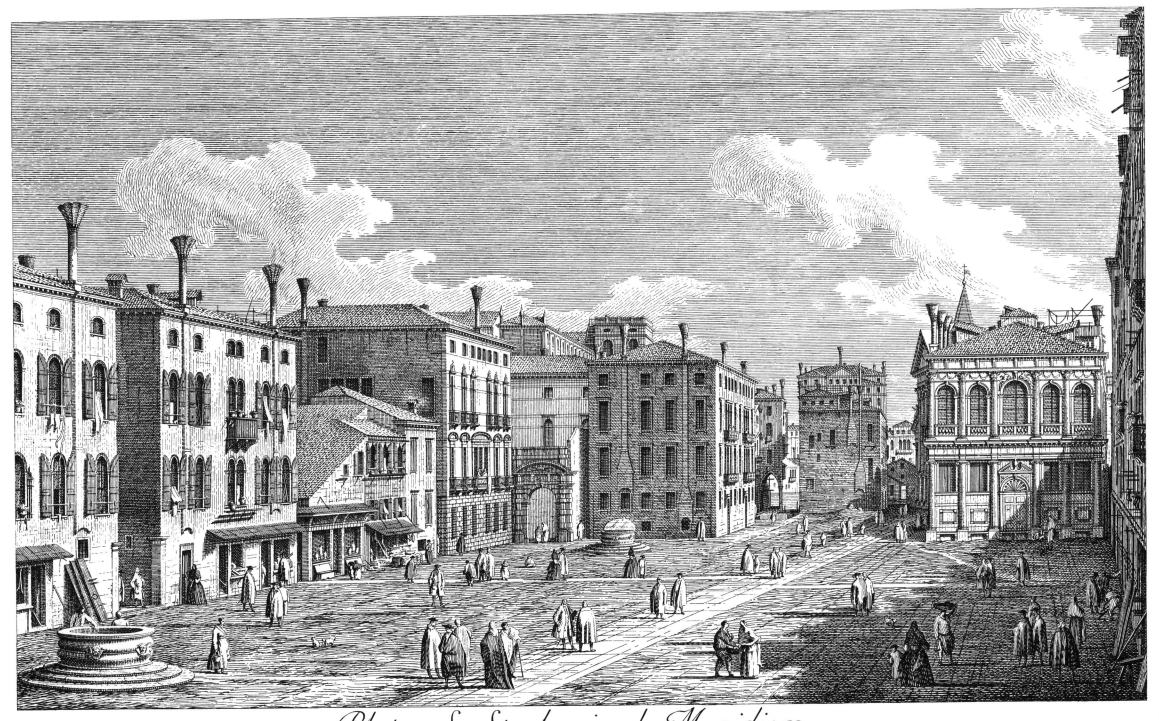

Platea S. Stephani ad Meridiem.

VII.

Campo Sta. Maria Formosa.

Most visitors to Venice pass through the Campo Sta. Maria Formosa either on their way to visit the Querini-Stampalia Library and Gallery, which are behind the church, or the church of SS. Giovanni e Paolo and the Colleoni statue, which are reached from a *calle* on the left of the picture. For Venetians living in this neighbourhood, however (and it is a densely populated neighbourhood), the *campo* is their market-place, providing a wide selection of clothes and footwear as well as the usual variety of food. In Canaletto's time it was much used for bull-fights and open-air theatrical performances.

The palaces bear the names of the eminent families for whom they were built, often with the name of a later occupant added, as in the case of the Palazzo Malipiero-Trevisan facing us in the background. The Donà and Vitturi palaces are on the left, in shadow; at the door of the Palazzo Donà (the nearest) Ermolato Donà was murdered in 1450. Powerful as all these families were, none of them bore titles; they were known merely as *nobile huomine*, noblemen. In the nineteenth century the Austrians offered to make many of them Counts of the Austrian Empire but relatively few accepted.

The church was rebuilt to the design of Mauro Coducci in 1492 on the site of one of ancient foundation which was the parish church of the *scuola*, or guild, of marriage-chest makers. Legend has it that in 944 some pirates hid themselves in the trees beside the church of S. Pietro di Castello, then the Cathedral of Venice and the scene of an annual ceremony at which the brides congregated with their dowries in their marriage-chests before being joined by their grooms; the pirates carried them all off to the town of Caorle, then on an adjoining lagoon, and would have raped and killed them but for the chest makers, who pursued them, rescued the brides and killed the pirates. In recognition the Doge paid an annual visit to Sta. Maria Formosa right up to the fall of the Republic in 1797.

The campanile bears a mask of Baroque design which moved Ruskin to describe it as "A head,—huge, inhuman, and monstrous,—leering in bestial degradation, too foul to be either pictured or described, or to be beheld for more than an instant."

Original painting: unknown; Constable refers to a painting in an Italian private collection (in 1960) which corresponds more closely to the engraving than a similar painting in the Bedford series.

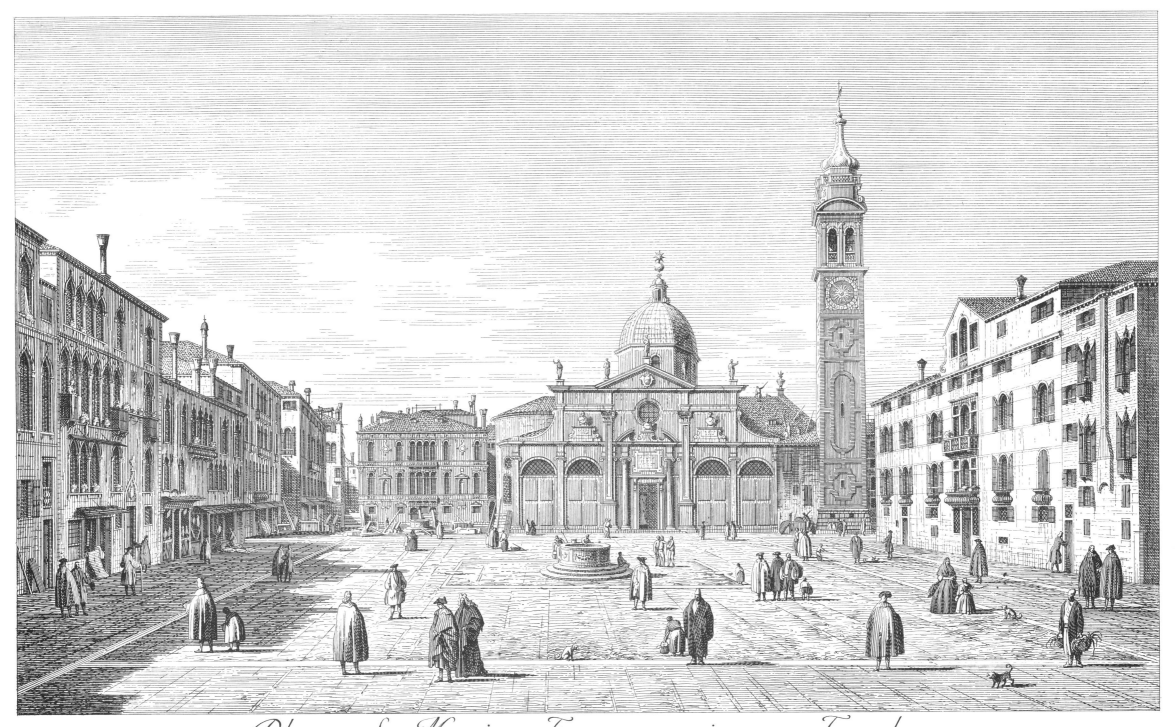

Platea S. Mariae Formosae, ejusque Templum.

VIII.

Campo dei Gesuiti.

The Jesuits' church, the ornate façade of which is seen on the right of the picture, is close to the Fondamente Nuove, or new embankments, which were built in 1589. Here we can walk beside the northern shore of the city and look across the lagoon to the cemetery island of S. Michele, the neighbouring island of Murano with its famous glass factories and, if the atmosphere is clear, to the island of Torcello in the distance. A glimpse of the lagoon may be seen in the background. The building in the right foreground was formerly the Jesuits' Convent but is now a barracks.

The Jesuits bought their site from the Government in 1657, their predecessors, the Crociferi, having been expelled and their property confiscated. The Manin family, who had the dubious distinction of providing the last Doge, Ludovico Manin, bore the cost of the façade, and the extraordinary interior was completed in 1729. It is a splendid example of Baroque ostentation, even the apparently damask curtains of the pulpit being in fact made of marble.

In the foreground is the Ponte dei Gesuiti (without parapets) and beyond it on the left is part of the palaces built in the sixteenth century for the Zen family and formerly decorated with frescoes by Tintoretto on the façade. Several members of the Zen family achieved fame in the fourteenth century as explorers and, later on, as soldiers.

The building beyond the Zen palaces was originally the Hospital and Oratory of the Crociferi and the surrounding houses were occupied by the lesser *scuole*, or guilds. A number of tablets may still be seen marking the sites of, for example, the guildhalls of the caskmakers, the makers of fringe and gold lace and the tailors.

Before the Fondamente Nuove were built this was an area where many Venetians built smaller palaces with gardens running down to the waters of the lagoon. Titian had one of these and a visitor has described how he went to visit the great artist and how, before dinner, they sat in the garden looking across to Murano, the water swarming with gondolas "adorned with beautiful women and resounding with varied harmonies." With the building of the new embankments the houses lost their view and privacy and the district became a slum, as it still is.

Original painting: Alemagna Collection, Milan; formerly Harvey series.

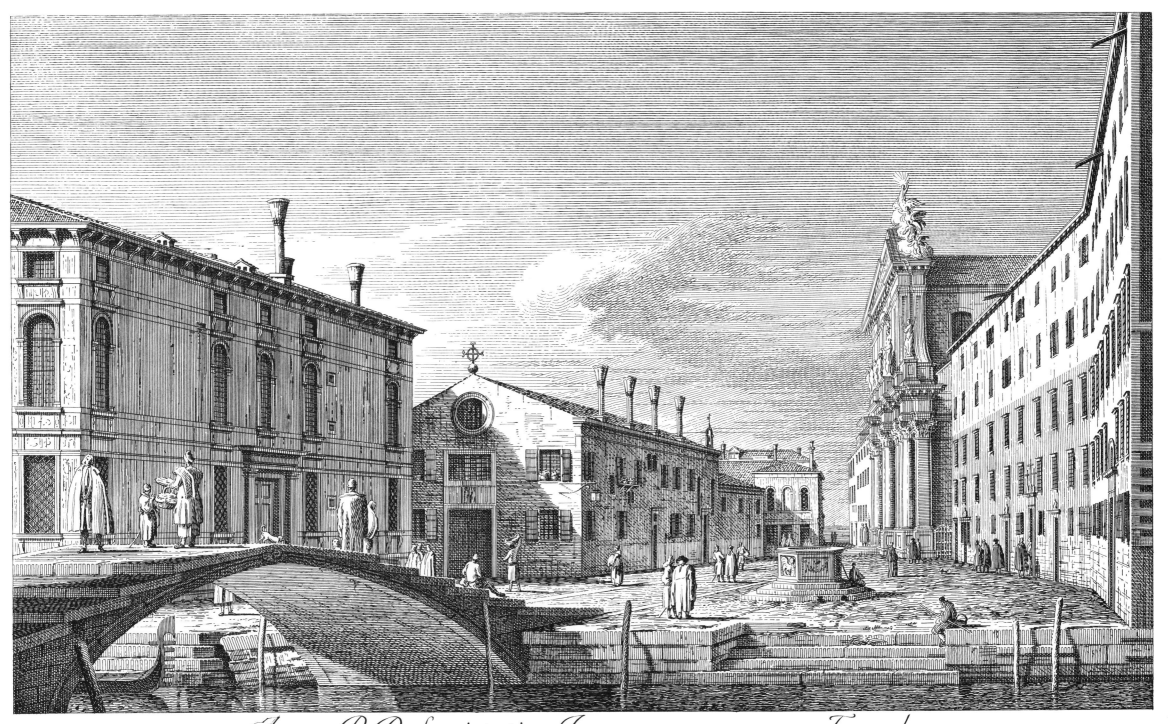

Area P.P. Societatis Iesu cum eorum Templo.

IX.

SS. Apostoli: Church and Campo.

The church of the Apostles is said to mark the spot where the first refugees from the mainland came when they began to settle on the islands which were later to be called Venice. When Canaletto painted his picture it was possible to reach the *campo* on foot only by means of a maze of narrow *calli* which even Venetians must have found it difficult to thread their way through. Access by water, on the other hand, was always easy by means of the broad Rio dei SS. Apostoli, which is seen in the foreground; it runs from the Grand Canal (left of the *campo*) at a point a short distance above the Rialto Bridge, past the Campo SS. Apostoli, and a little later changes its name to the Rio dei Gesuiti and enters the northern part of the lagoon behind the church of the Jesuits, which we saw in the last picture.

Today Venice's broadest street begins at this *campo* and bears throngs of pedestrians north-west to the Cannaregio Bridge and then on to the railway station. Nothing better illustrates the city's former reliance on water transport than the fact that this street, the Strada Nova, was not built until 1872. In former times all travellers arriving by ferry from the last mainland town of Mestre disembarked at the Cannaregio Bridge. Those wishing to make their way on foot to the Rialto Bridge or any point south of it would need to pass through the Campo SS. Apostoli but there was no street leading to it from the Cannaregio. Travelling on foot for any distance must have been rare in Venice.

The building on the left of the picture was originally the Scuola del Angelo Custode, built in the early eighteenth century. In 1812 it was given to the German Protestants and remained for many years the only Protestant church in the city. Beyond it is one of the fifteen palaces owned by the Corner family and bearing their name. The eighteenth-century tower of the campanile is a familiar landmark from many points in the city.

Canaletto painted his picture from just outside the former palace of Marin Falier, who became fifty-fifth Doge in 1354. He quickly tired of the impotence which had become the Doge's lot since changes in the constitution in 1297 and of the ceremonial which was all that remained to him. Accordingly he tried to exercise power himself, as a result of which he was charged with conspiracy against the state and beheaded, his head being shown to the people from the balcony of the Doge's Palace. In place of his portrait among the first seventy-six Doges in the great Council Chamber of the palace there is a black square.

Original painting: Alemagna Collection, Milan; formerly Harvey series; the correspondence is close but not complete.

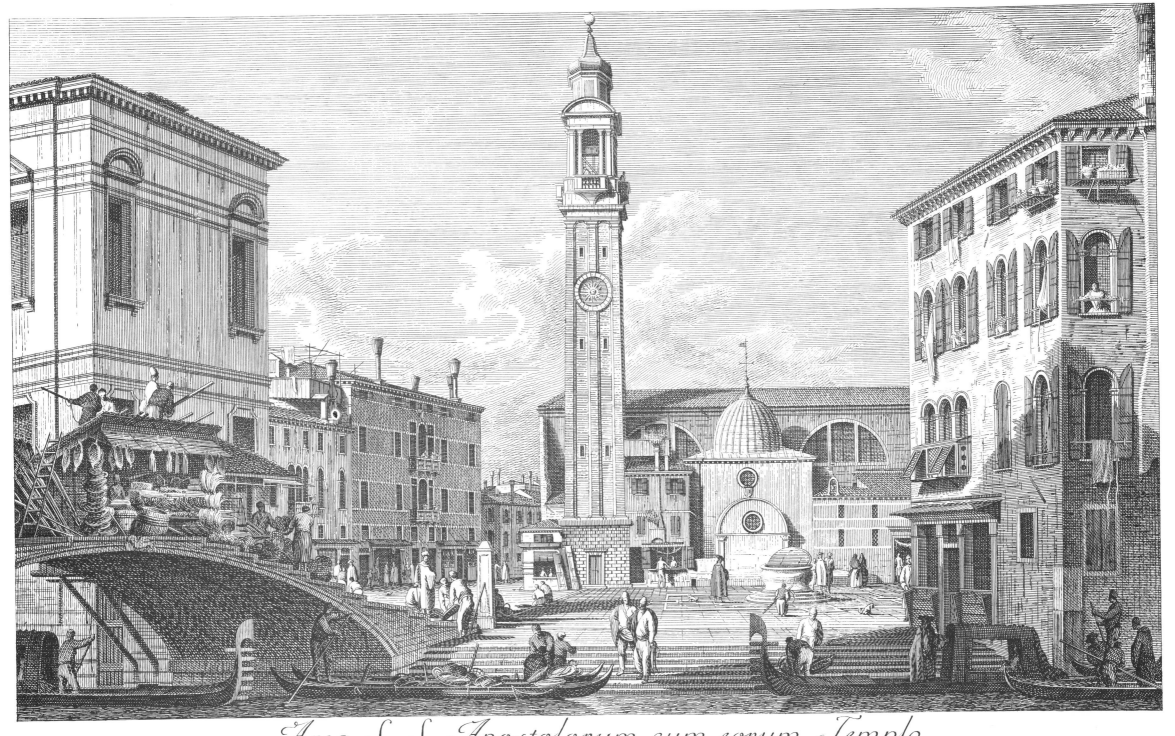

Area S. S. Apostolorum cum eorum Templo.

X.

Piazza S. Marco: looking West along the Central Line.

At last we are in the Piazza S. Marco, standing in front of St Mark's with the Piazzetta on our left (both invisible) and looking towards the now demolished church of S. Geminiano; the Clock Tower, which we saw in the background of Part I, No. XIV, is on our right, also invisible. It is to the Piazza that every Venetian hurries when there is a ceremony or when his emotions are aroused or even when his day's work is done: there is only one Piazza in the city, all other squares being called *campi*. It is in the Piazza that all tourists first gather, just as they have done since they met in Venice in the days of the Crusades and then the Pilgrimages. Napoleon called it the drawing-room of Europe and that was what it had become by his day.

On the left is the base of the Campanile, which collapsed in 1902 and was replaced by an exact copy. In front of it is part of the Loggetta, built in 1540 by Sansovino and first used as a clubhouse, then a guard-room; it was demolished when the Campanile fell but the original pieces were fitted together and it now stands as it did in Canaletto's day. There are canvas-covered booths for stallholders both beside the Campanile and between the bronze bases of the flagpoles from which the red and gold standards of the Republic were flown.

On the right are the Procuratie Vecchie, the old residences of the Procurators, begun in 1480. A hundred years later the nine Procurators, whose duties were largely ceremonial, required more space so the Procuratie Nuove (new) were built on the opposite side of the Piazza. At first Sansovino's Library in the Piazzetta was extended into the Piazza by ten arches with an additional storey; later the extension was carried along the whole south side and, without the top storey, as far as the church on the west side.

Napoleon converted the whole of the Procuratie Nuove into a palace for himself and he demolished S. Geminiano to provide an entrance to it. The former palace now houses the Correr Museum. Within the arcades which now extend round the three sides of the Piazza are some of the city's finest shops and three famous cafés with their tables and chairs spreading well into the Piazza itself.

As in the case of the last pair of paintings for both Parts I and II, the originals of this and the next engraving are considerably larger than the remaining thirty-two. This pair is part of a series of eight Canaletto paintings which have been in the Fitzwilliam family since the eighteenth century.

Original painting: Earl Fitzwilliam, Milton Park, England; $29 \times 41\frac{1}{8}$ inches.

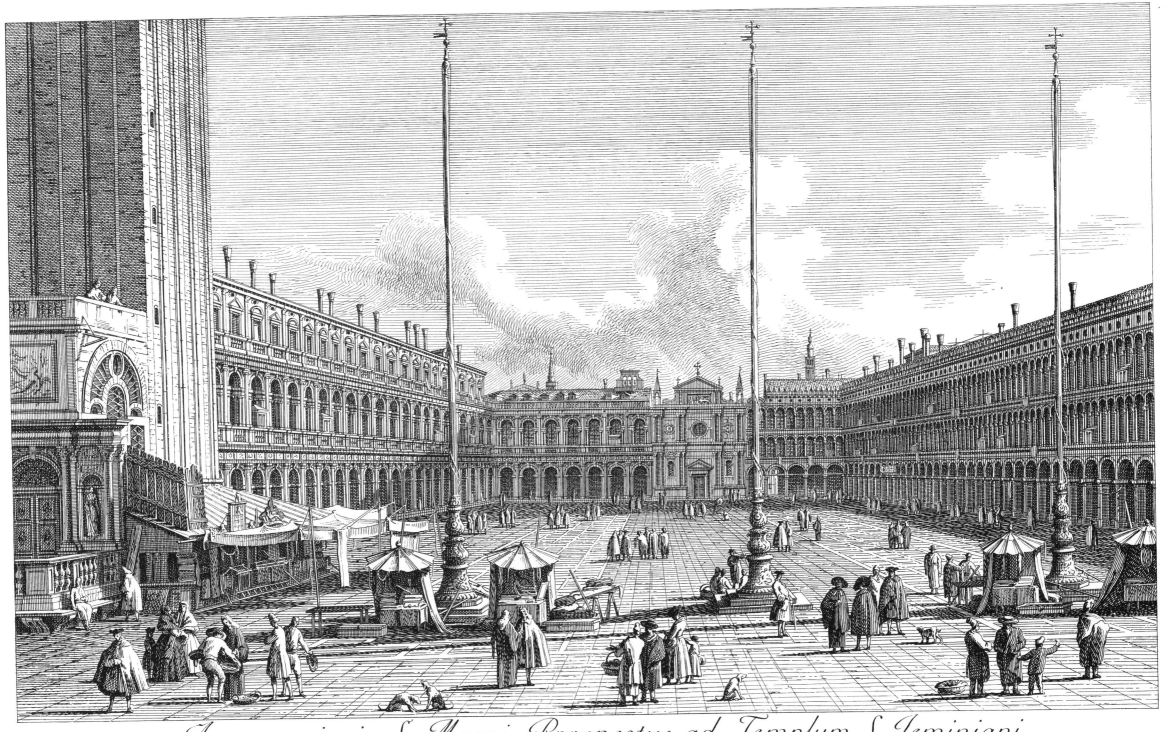

Areae majoris S. Marci Prospectus ad Templum S. Jeminiani.

XI.

Piazza S. Marco: looking East along the Central Line.

S. Geminiano is now behind us and we look down to St Mark's from near where Ruskin described it as seeming "to lift itself visibly forth from the level field of chequered stones." To the right of St Mark's, between the Campanile and the Procuratie Nuove, is a glimpse of the Doge's Palace, and to the left we see the Clock Tower and the little Campo S. Basso, now known as the Piazzetta dei Leoncini from its two red marble lions placed there in 1722.

Today's visitor can obtain the view from the window of the Correr Museum's pay-office, formerly the entrance to Napoleon's palace. The façade of S. Geminiano, seen in the previous engraving, provided no vantage point for Canaletto, who must have worked out his perspective in the studio. In the original painting the canvas-covered stall at the base of the Campanile which we saw in the last engraving has now become a stage with scenery, in front of which a crowd is waiting for the actors to appear; Visentini has substituted a drawn curtain for the scenery. The height of the Campanile in relation to its width is, as usual in Canaletto's painting, considerably exaggerated, although less so than in the case of other artists, particularly Francesco Guardi.

The first church of St Mark was built in the ninth century to house the body of St Mark, brought from Alexandria, according to legend, by two Venetian sailors. The third, and present, church was completed by 1094 but it did not become the Cathedral of Venice until 1807, S. Pietro di Castello bearing the title up to that date. Gradually, the garden in front of St Mark's, the *brolo*, developed into a *piazza* and it was first paved with tiles in 1264. Originally a flight of steps led up to St Mark's from the Piazza but every century or so the level was raised and today one steps down to enter the Cathedral.

The paving we see in the engraving was laid in 1722, the first time the Piazza had been paved in stone. The earliest known painting by Canaletto, now in Lugano, Switzerland, shows the old, irregular surface; thus we know the date by which Canaletto's career must have begun. He was then twenty-five; Joseph Smith was nearing fifty and Visentini was thirty-four. Twenty years were to elapse before Visentini's engraving of the present painting was published (there is reason to suppose it was in Smith's house until sold to the Fitzwilliam family). In those twenty years Canaletto must have trod every foot of Venice's narrow streets and have been oared in his gondola along every *rio*. He must have studied the view from hundreds of windows and from all this he found over 350 different subjects. The thirty-eight selected by Smith and Visentini for this book are but a small measure of his achievement.

Original painting: Earl Fitzwilliam, Milton Park, England; $29\frac{1}{2} \times 41\frac{5}{8}$ inches.

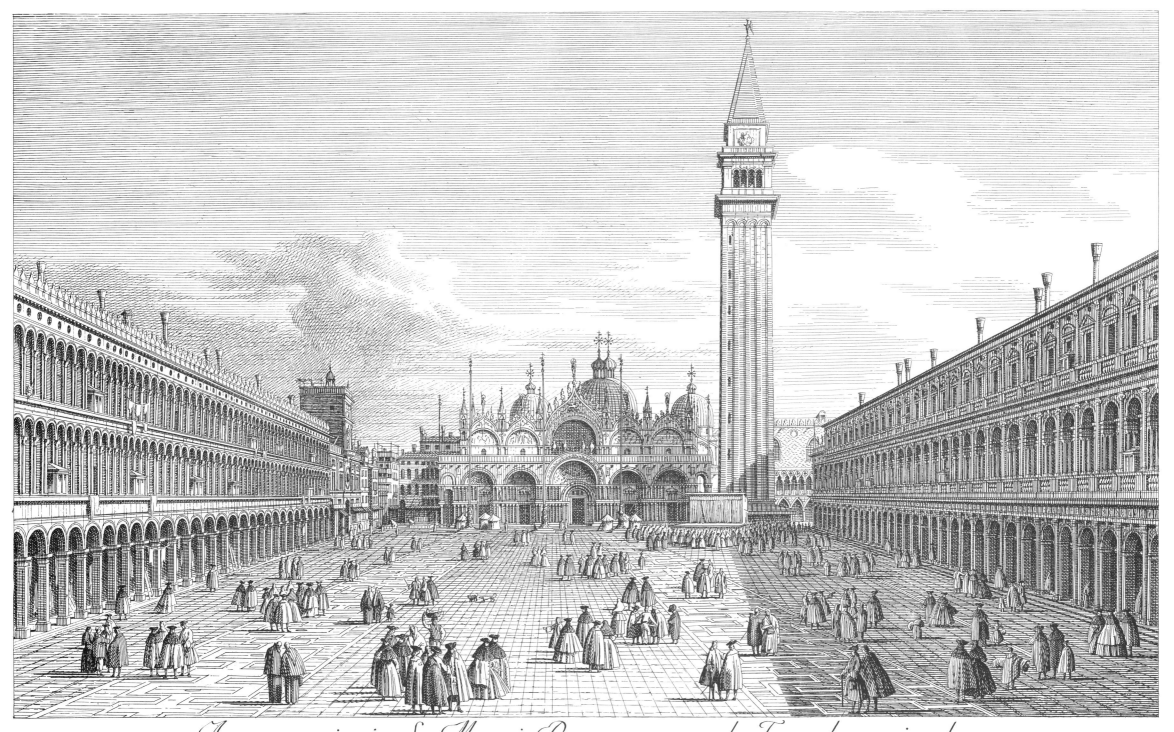

Areae majoris S. Marci Prospectus ad Templum ejusdem.

XII.